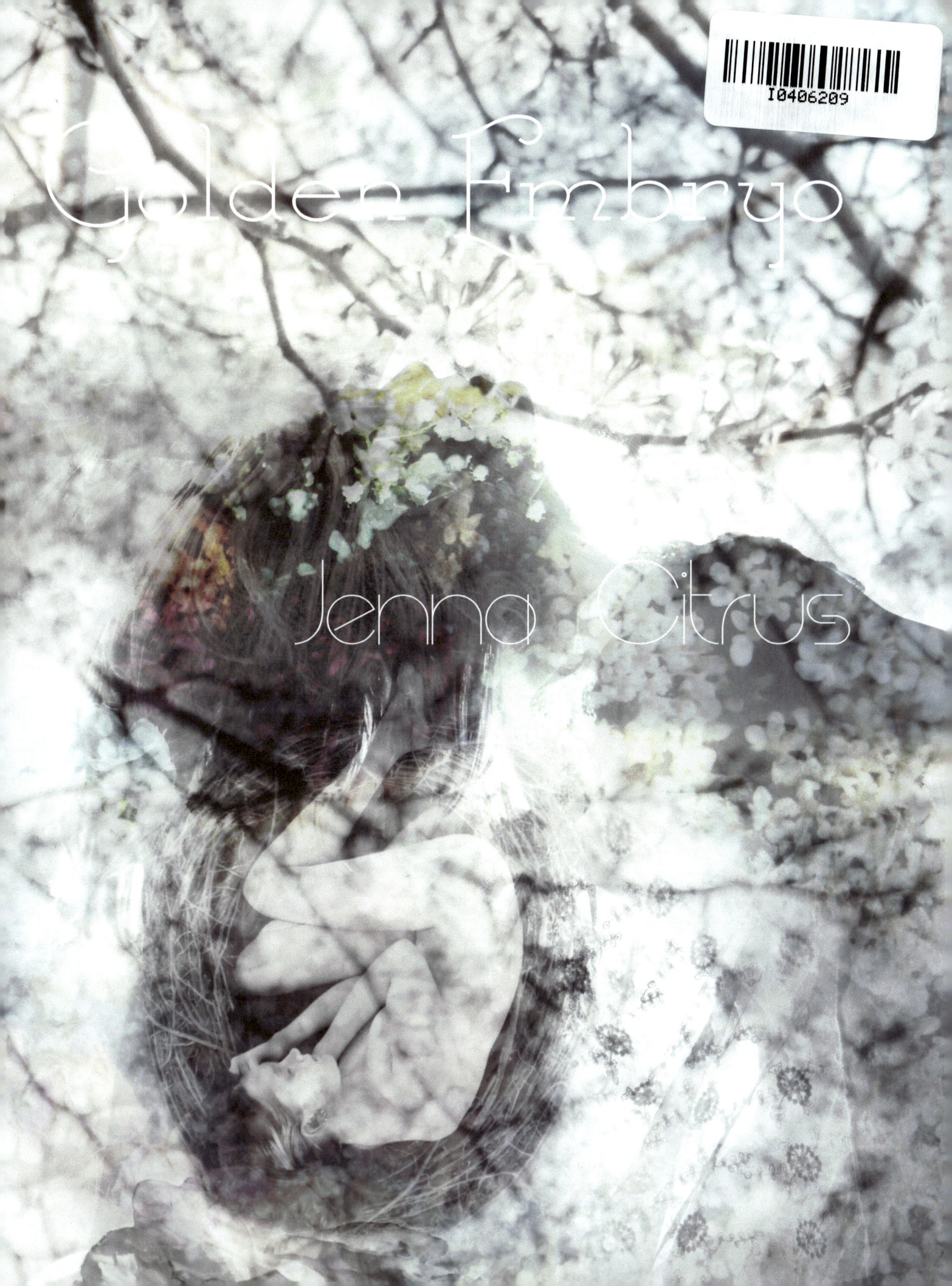

Copyright © 2013 by Jenna Citrus

All rights reserved
Printed in the United States of America
Published with Create Space LLC paperback 2013

Library of Congress

ISBN: 978-1492196495

Create Space
Charleston, SC
Printed in the United States

© All original content created by Jenna Citrus

© Interior and cover designs created by Jenna Citrus

December 2013

Imagery:
Collection of Light
&
Color

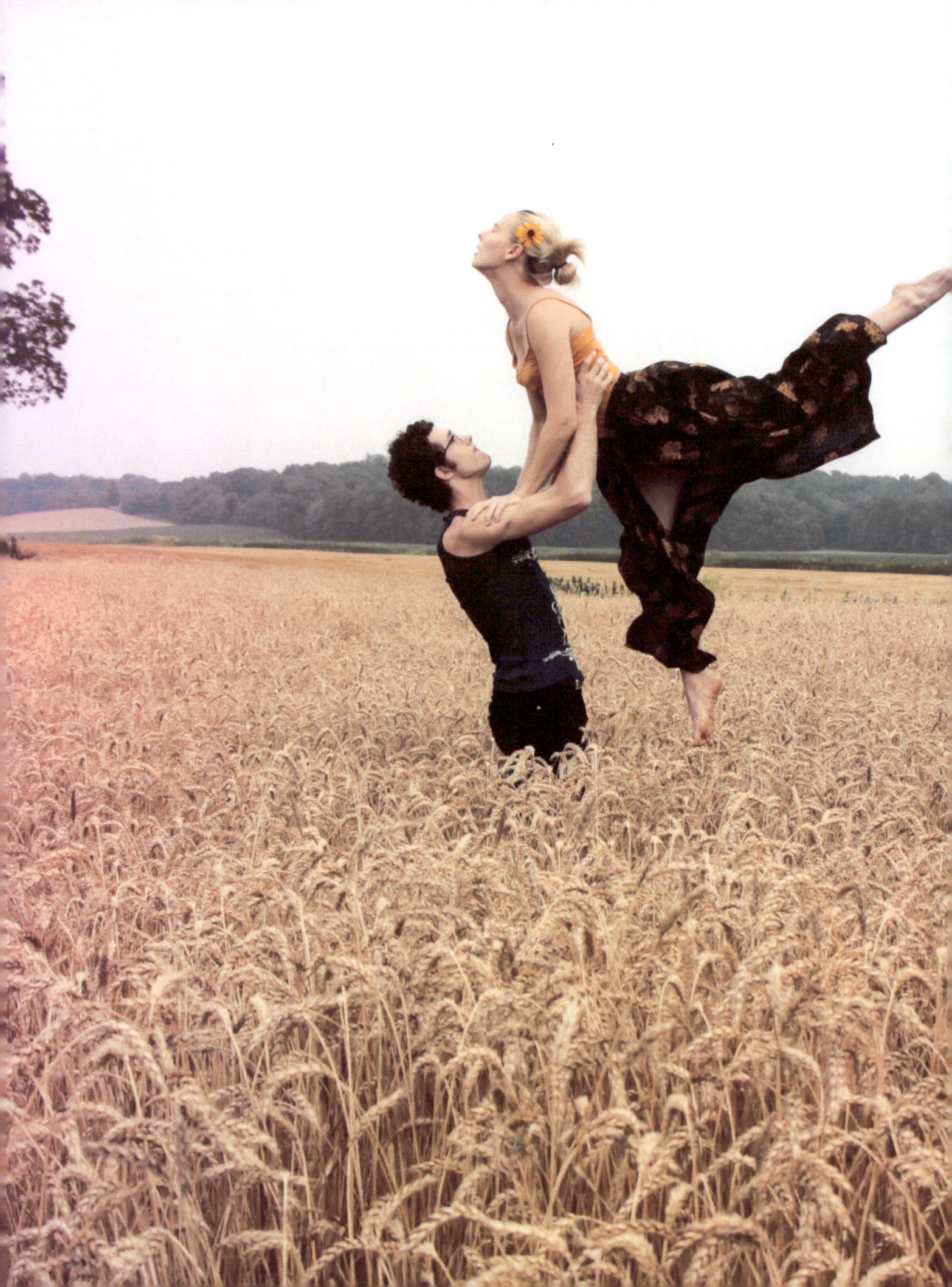

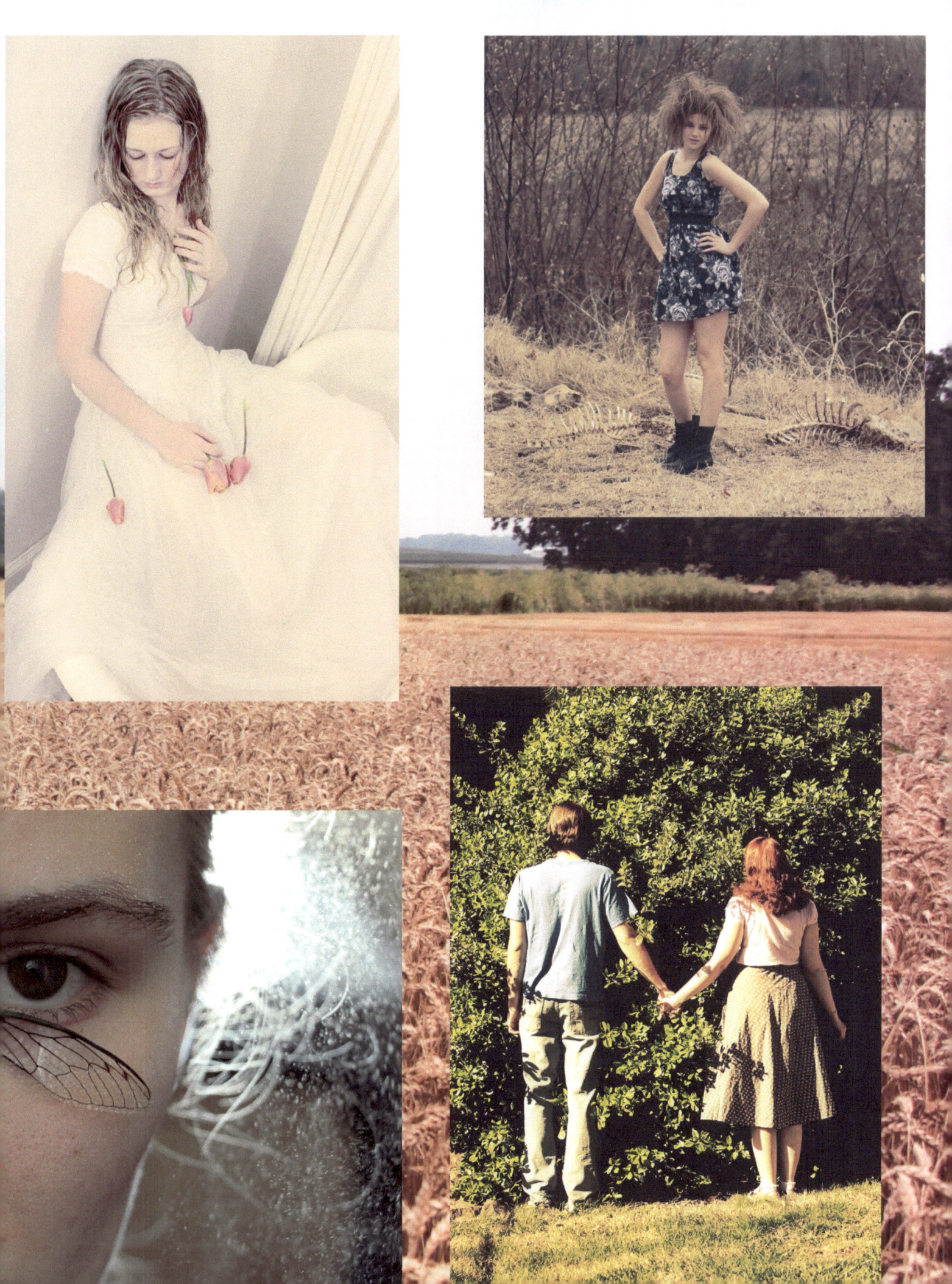

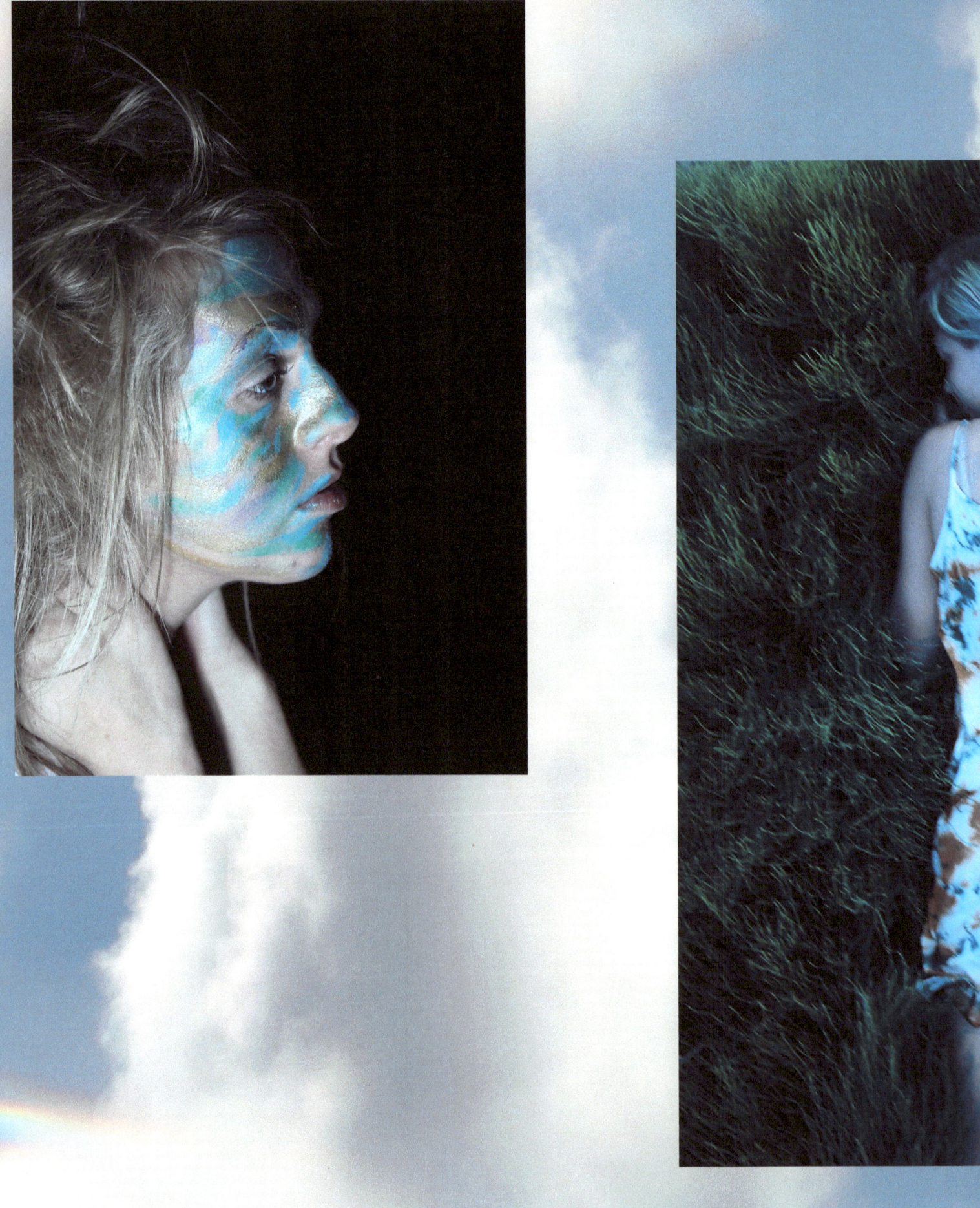

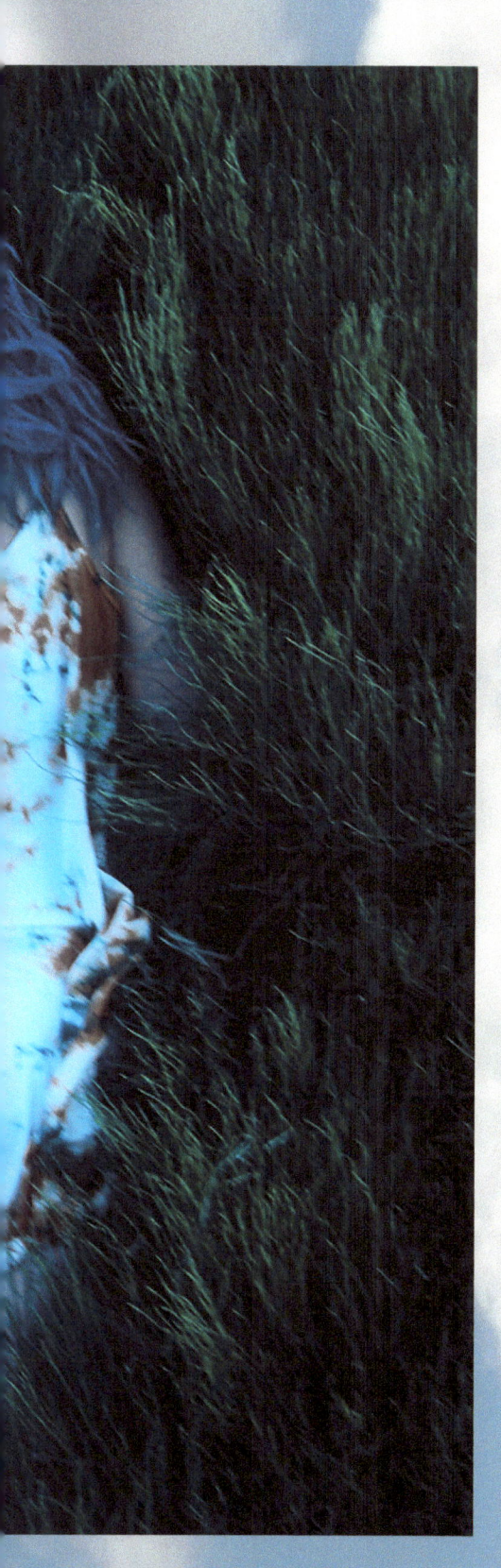
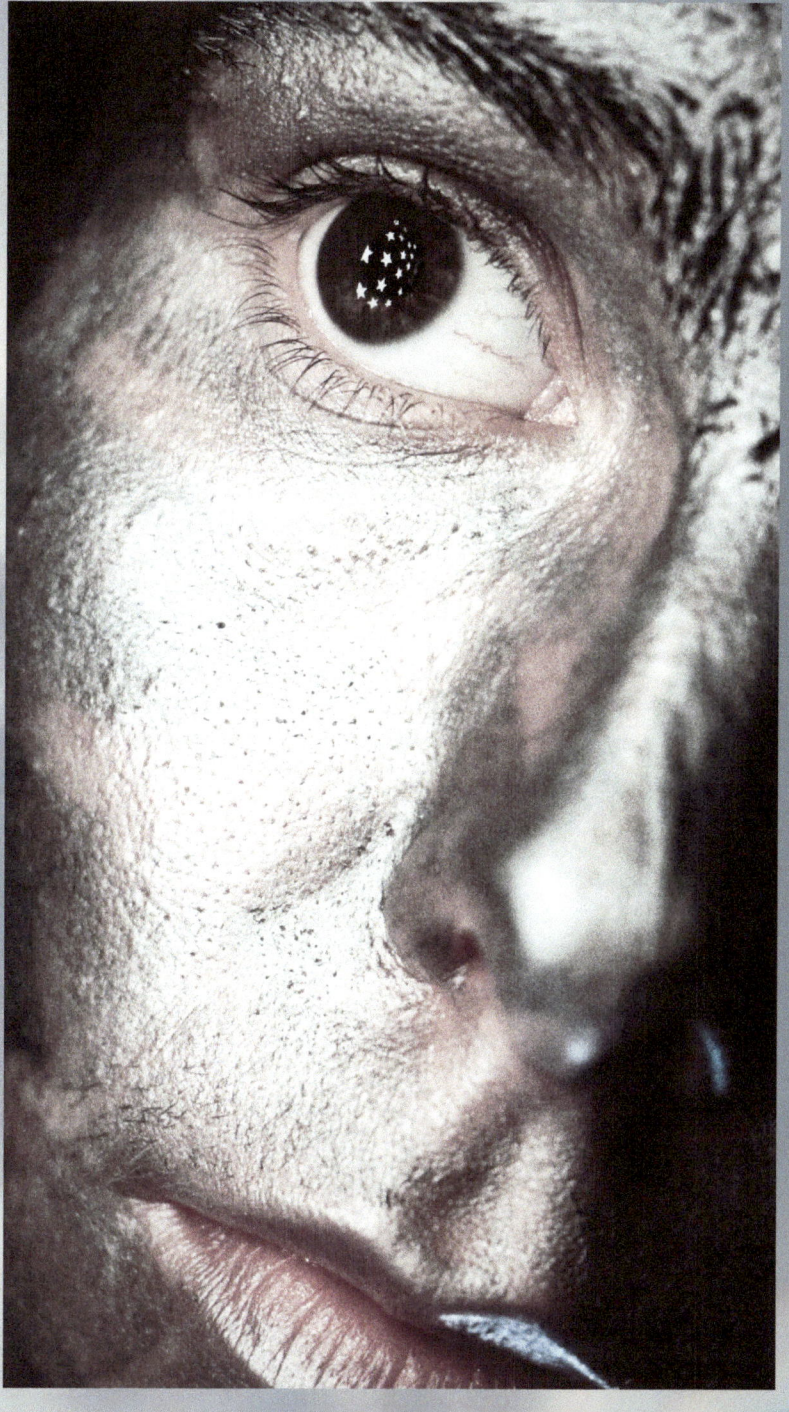

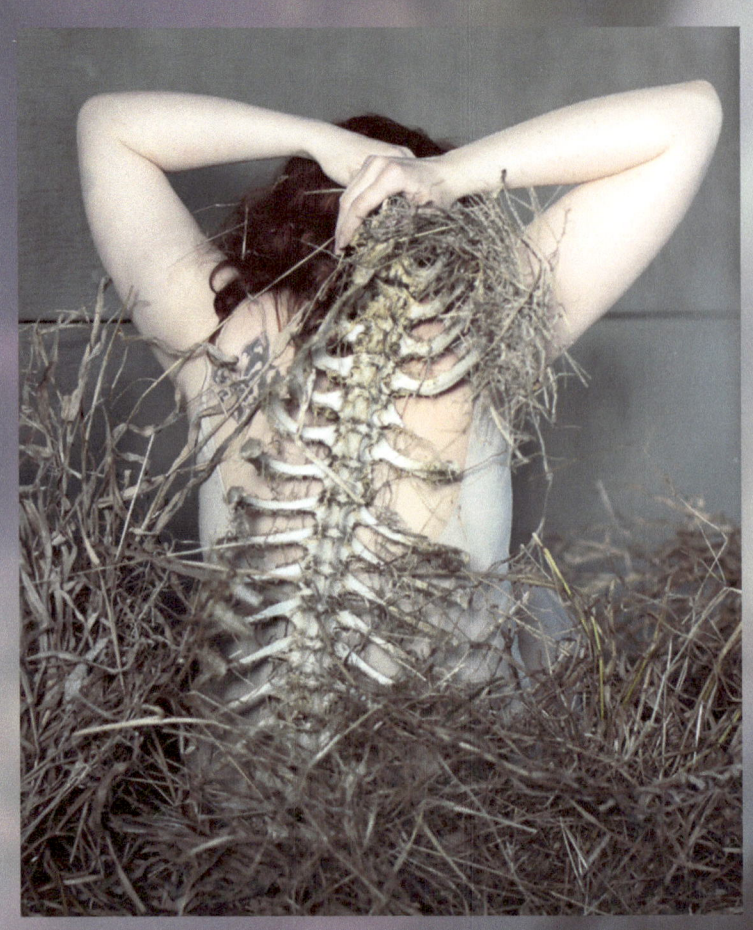
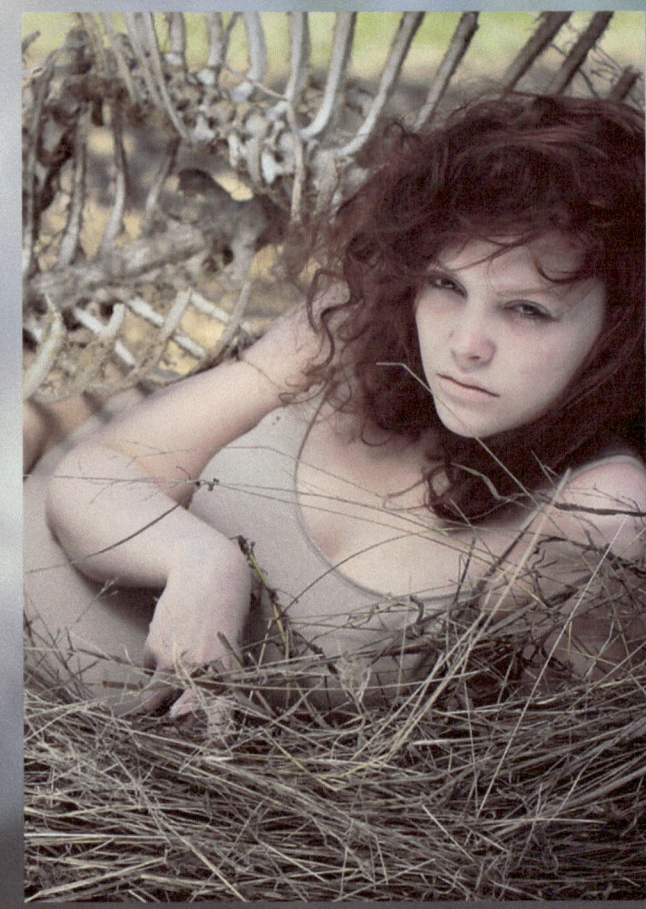
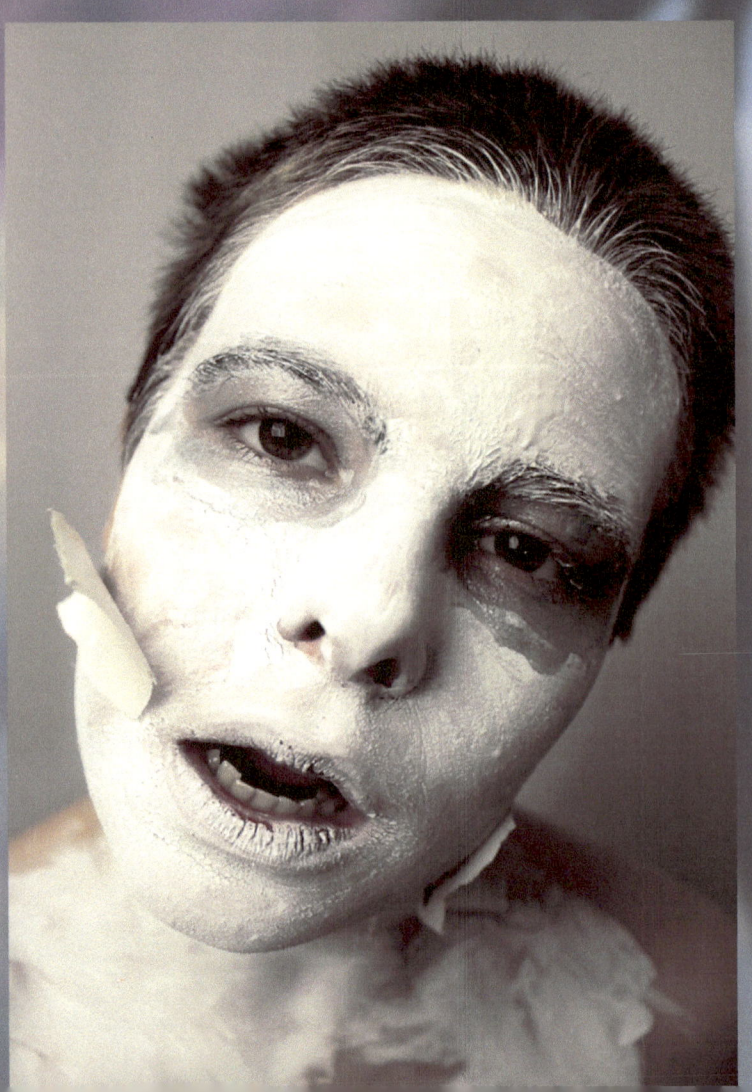
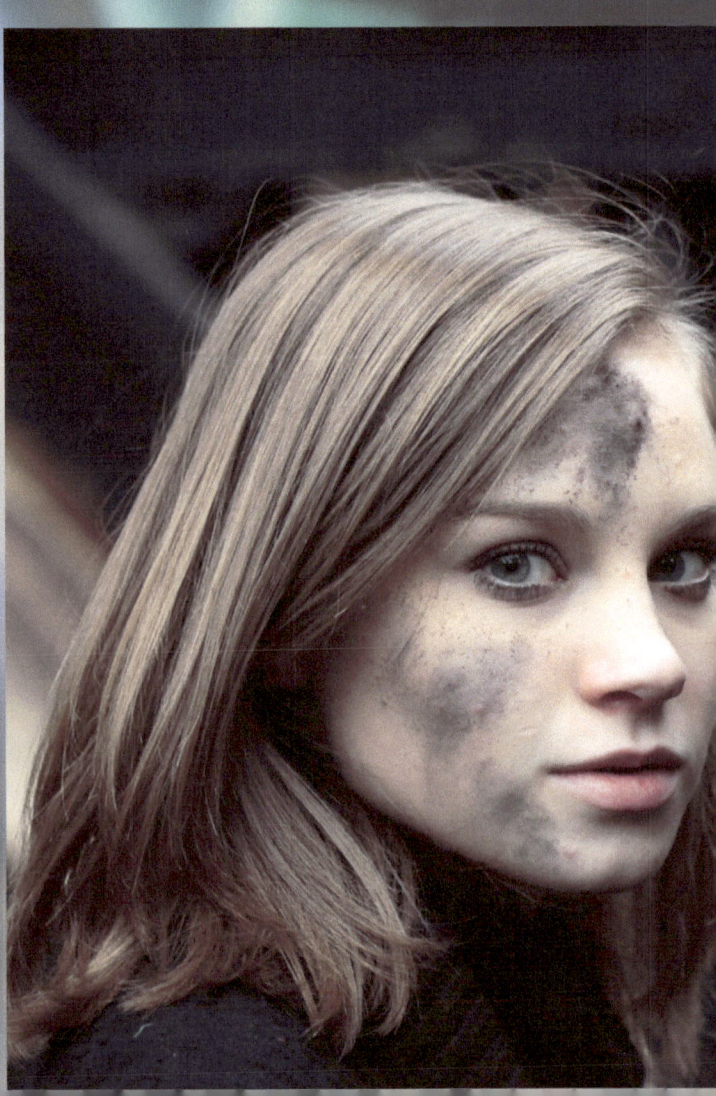

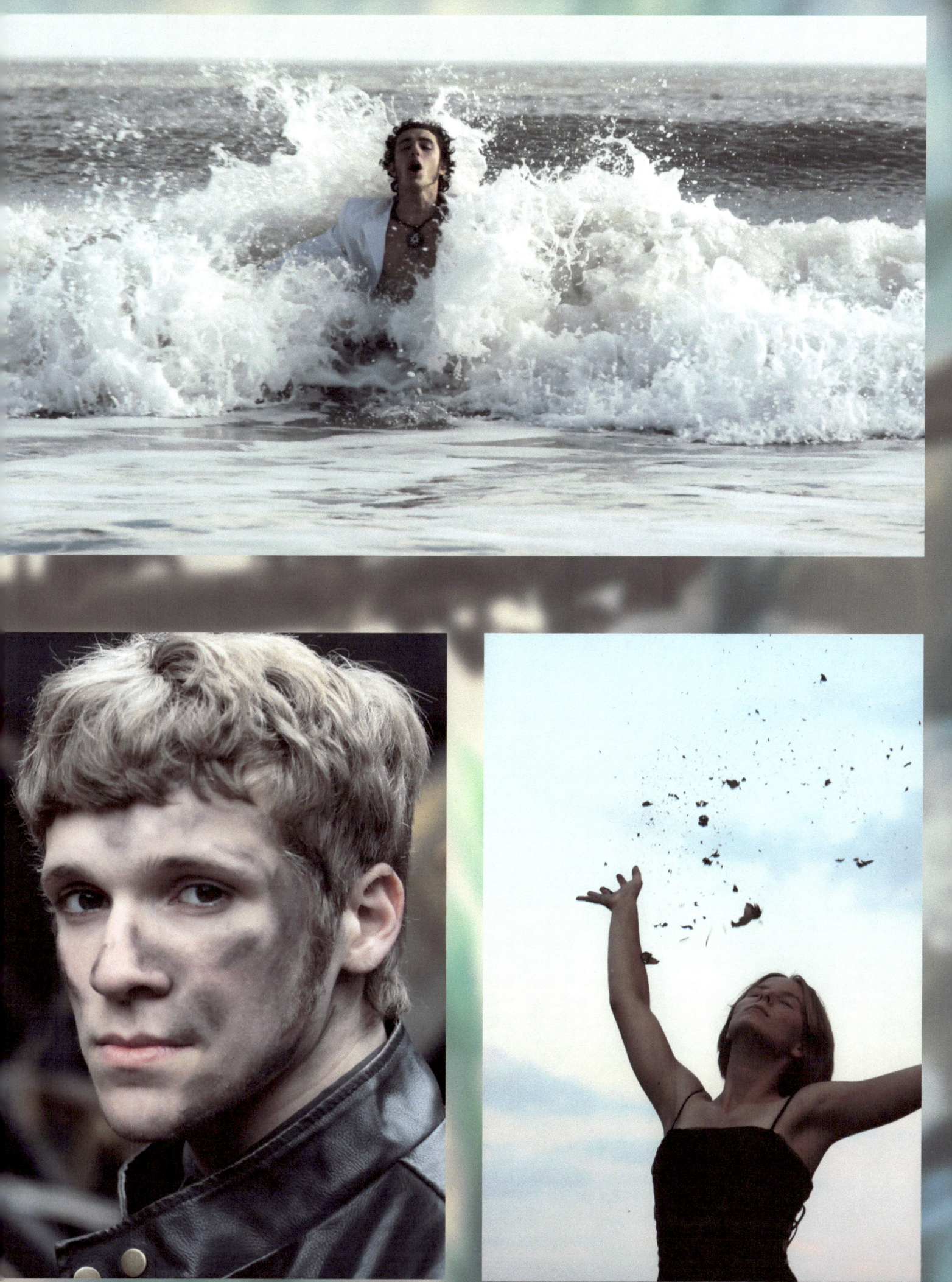

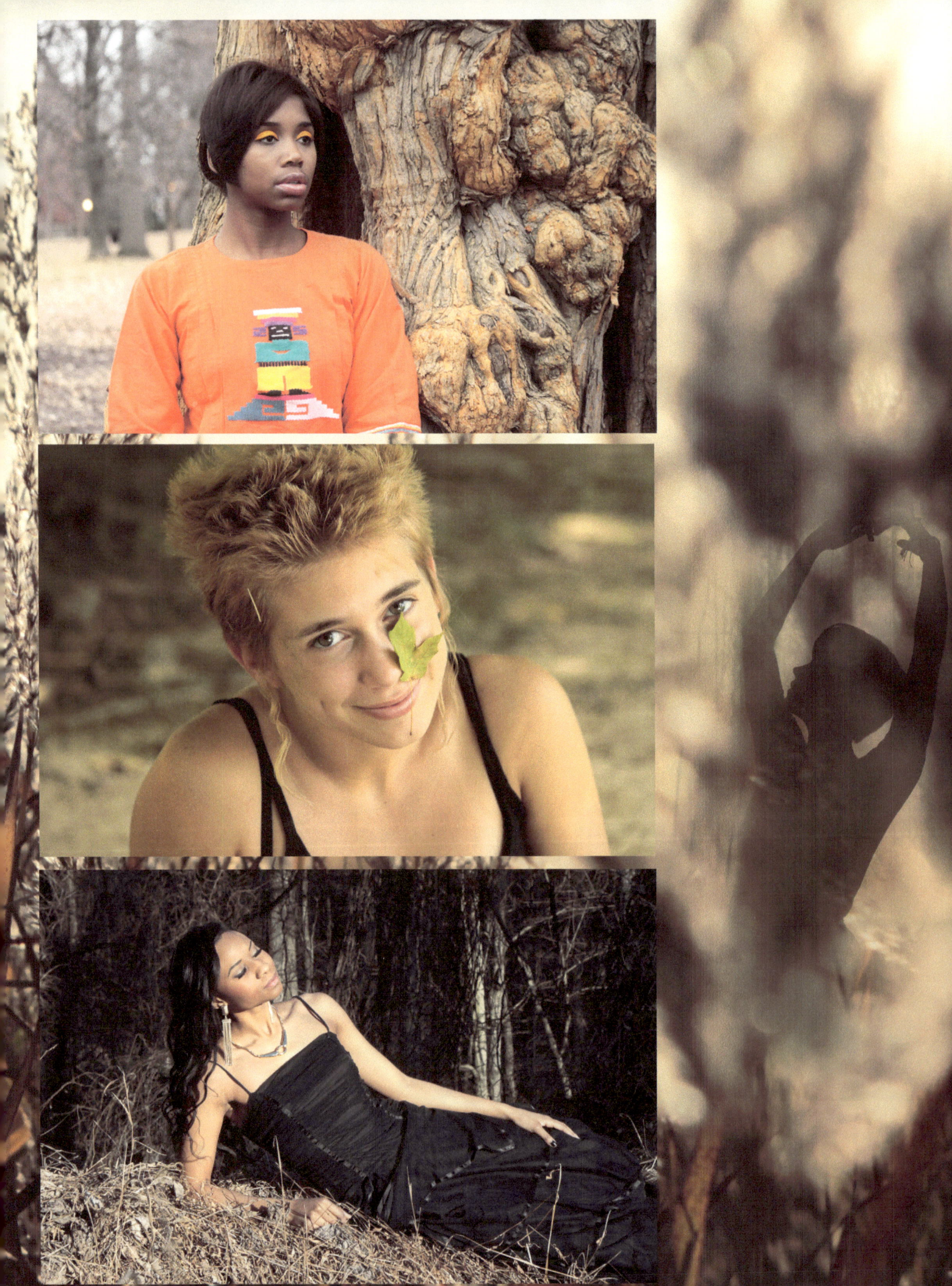

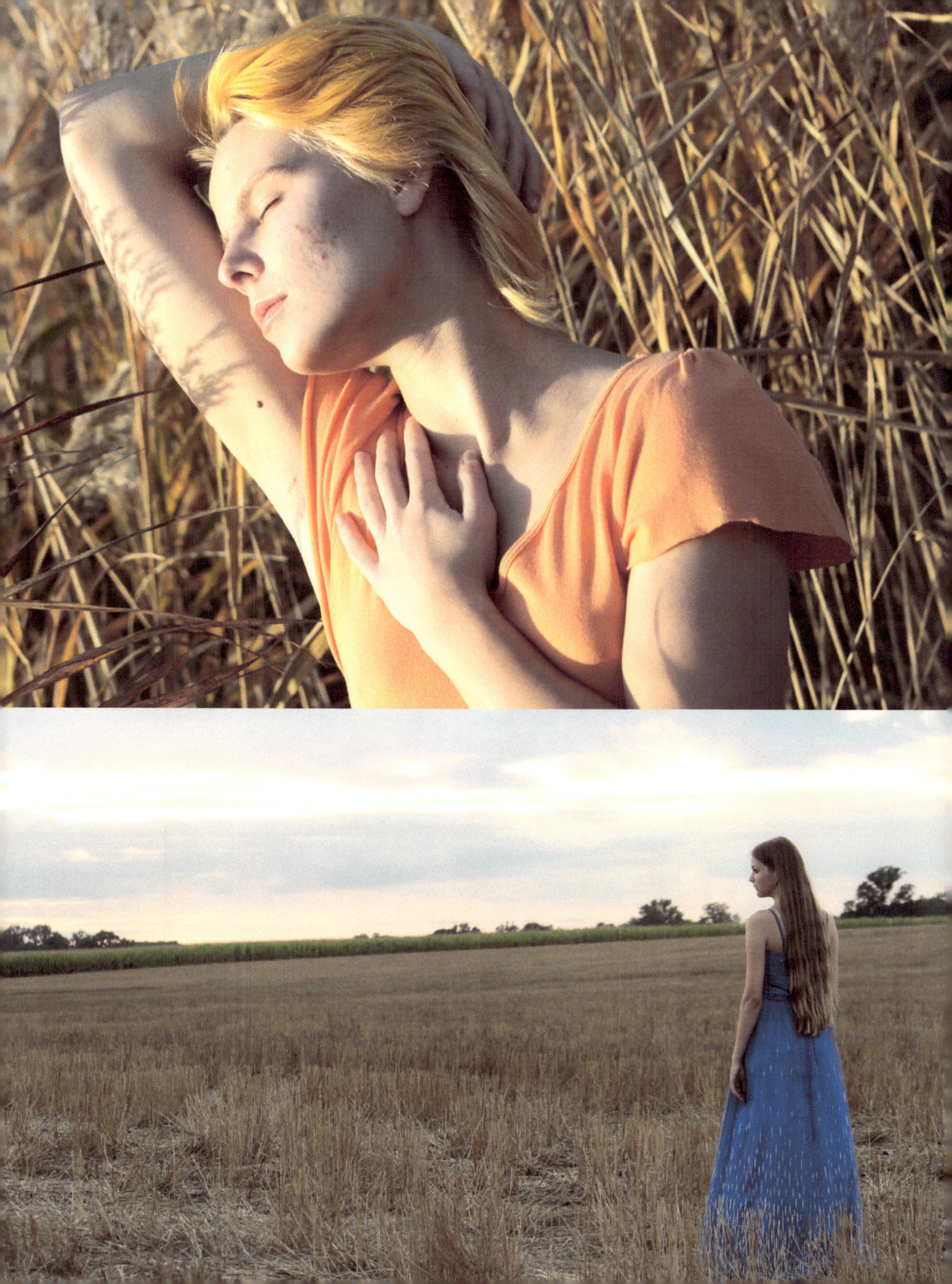

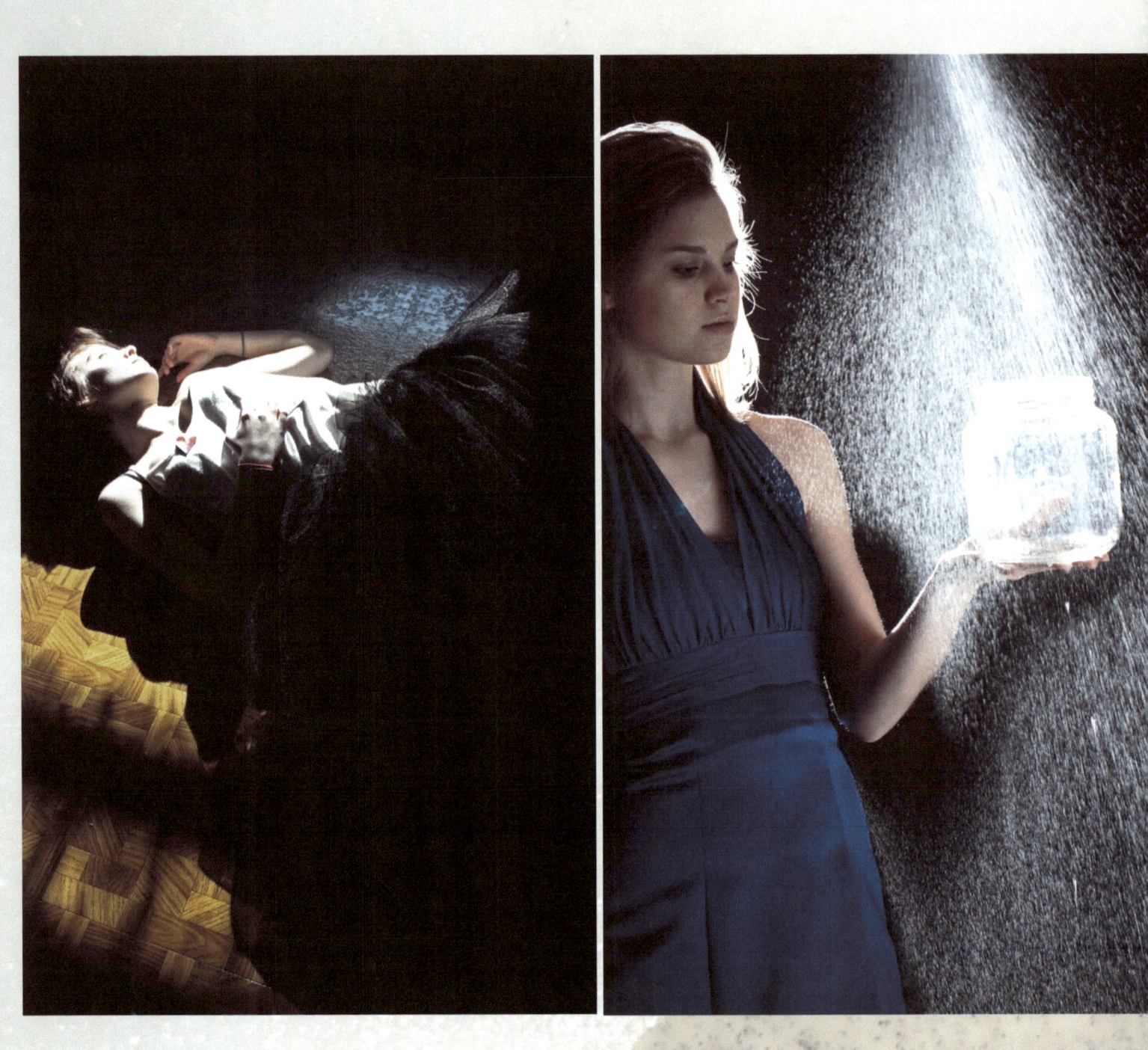

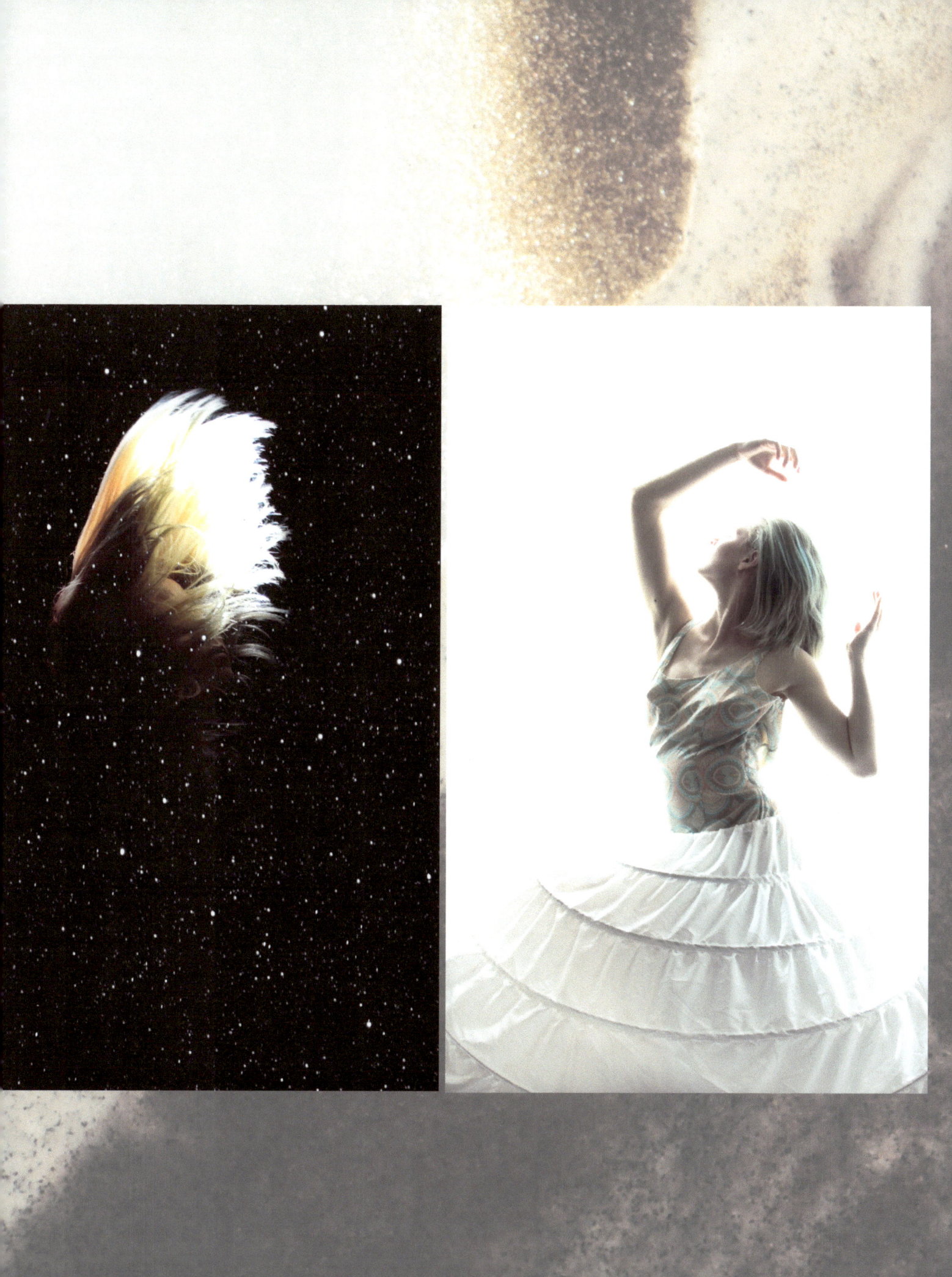

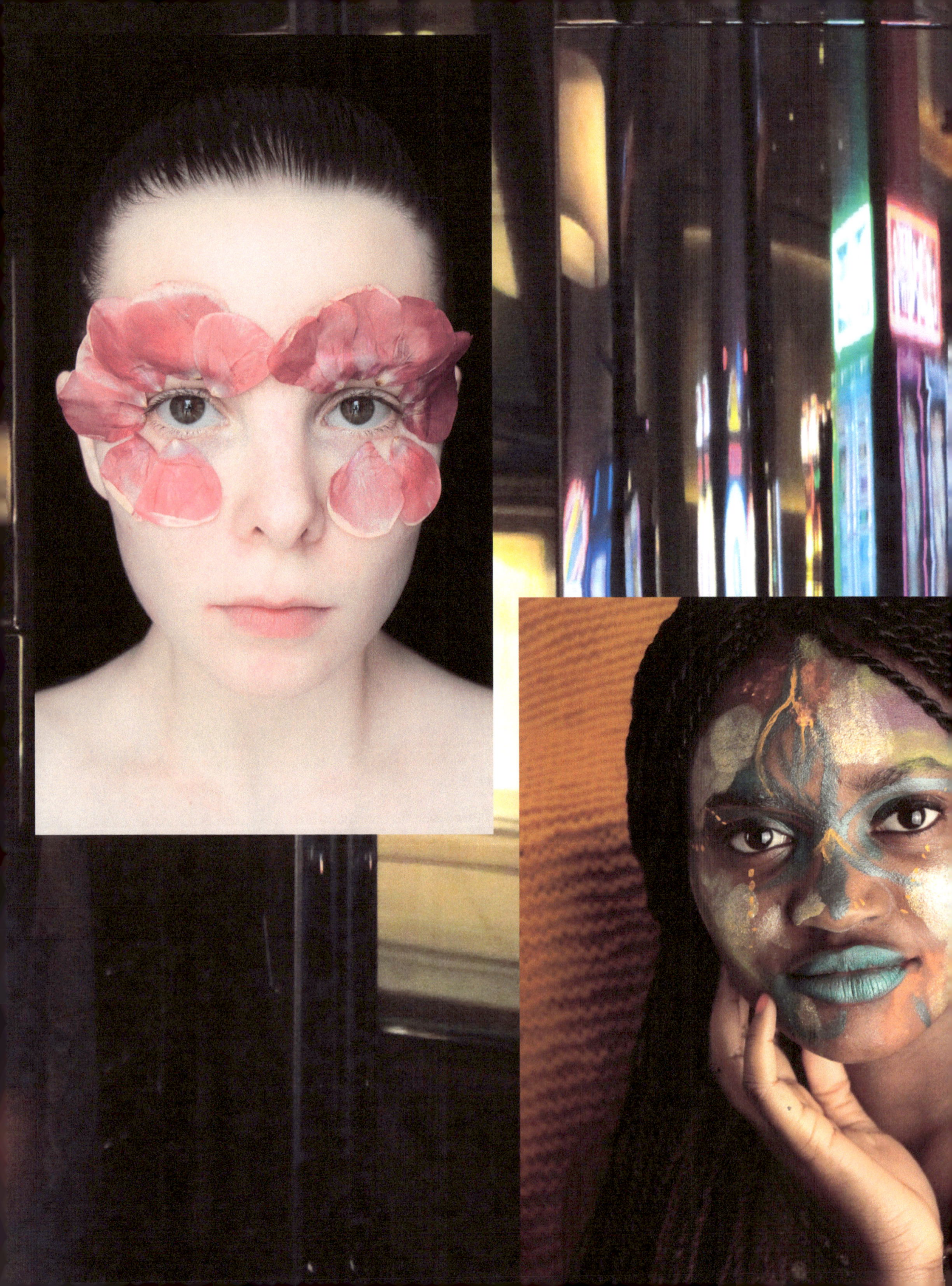

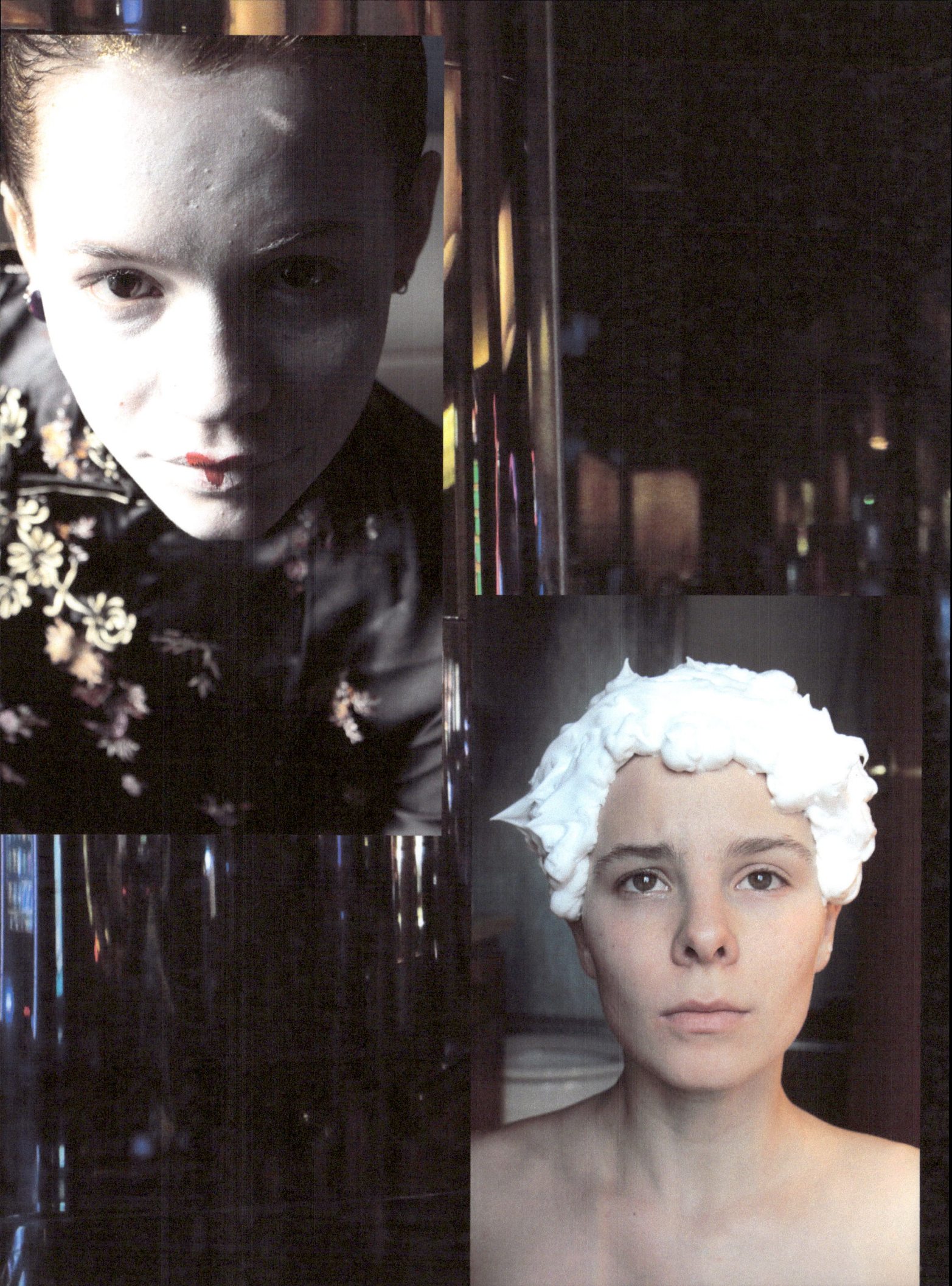

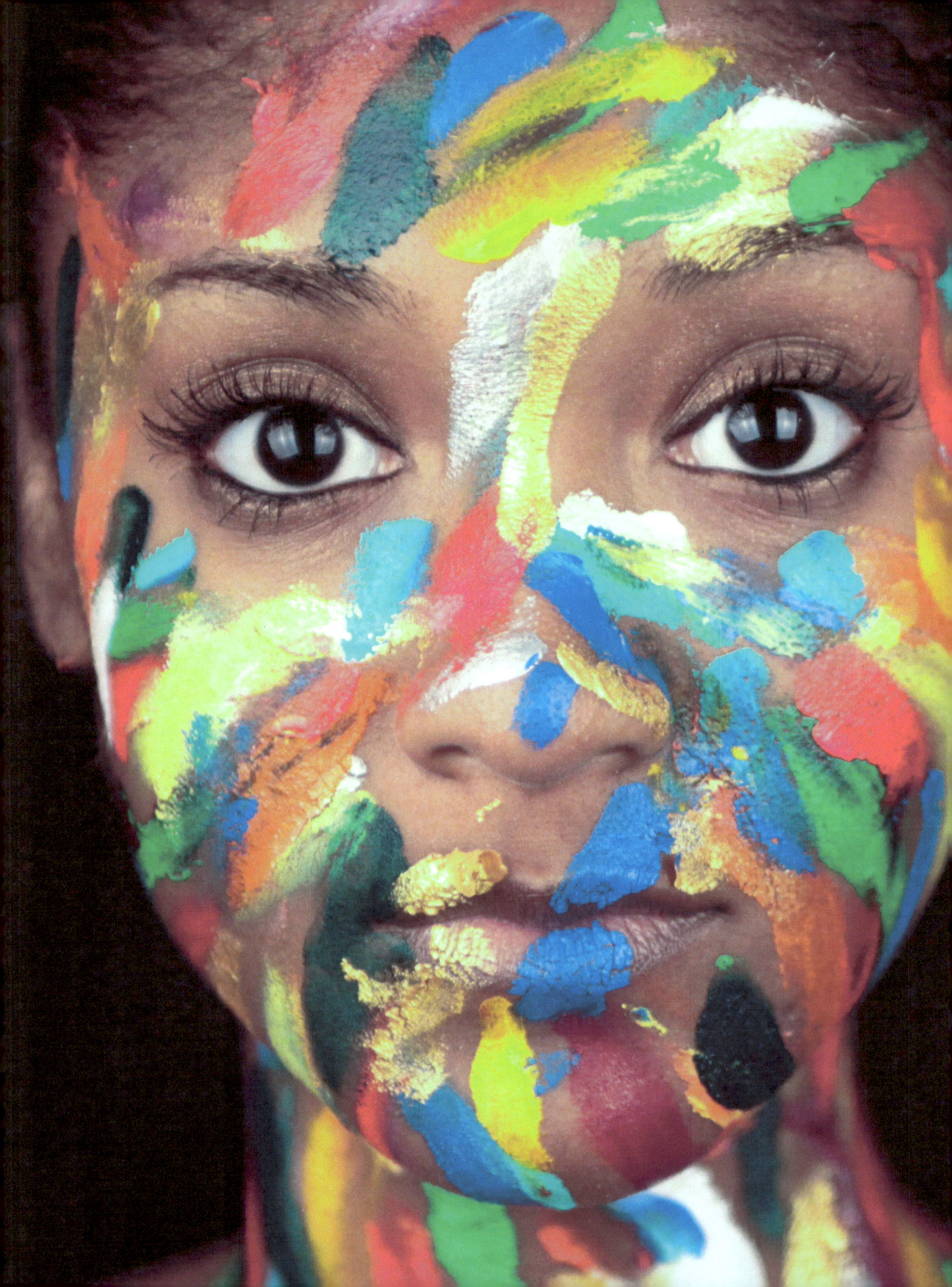

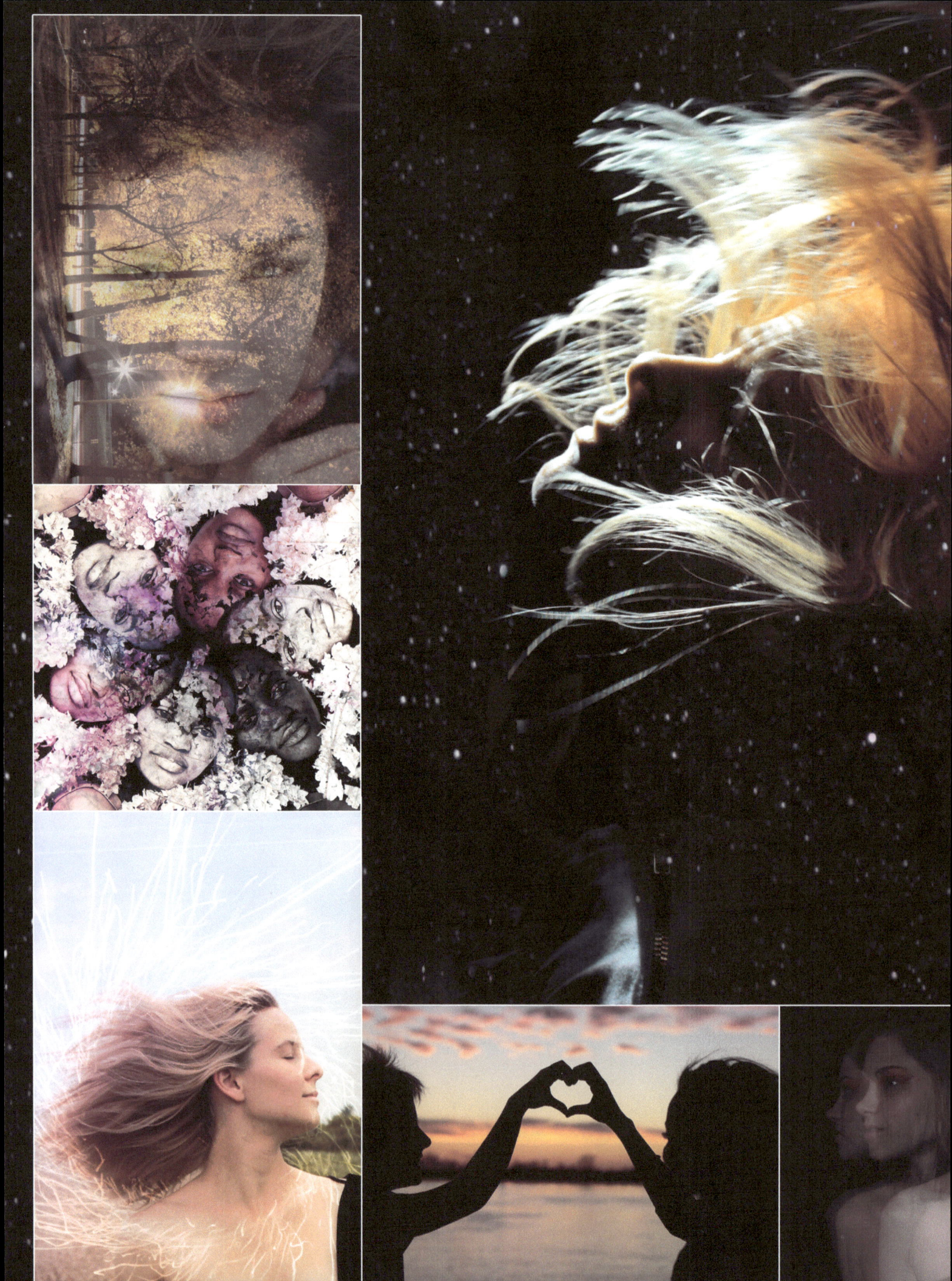

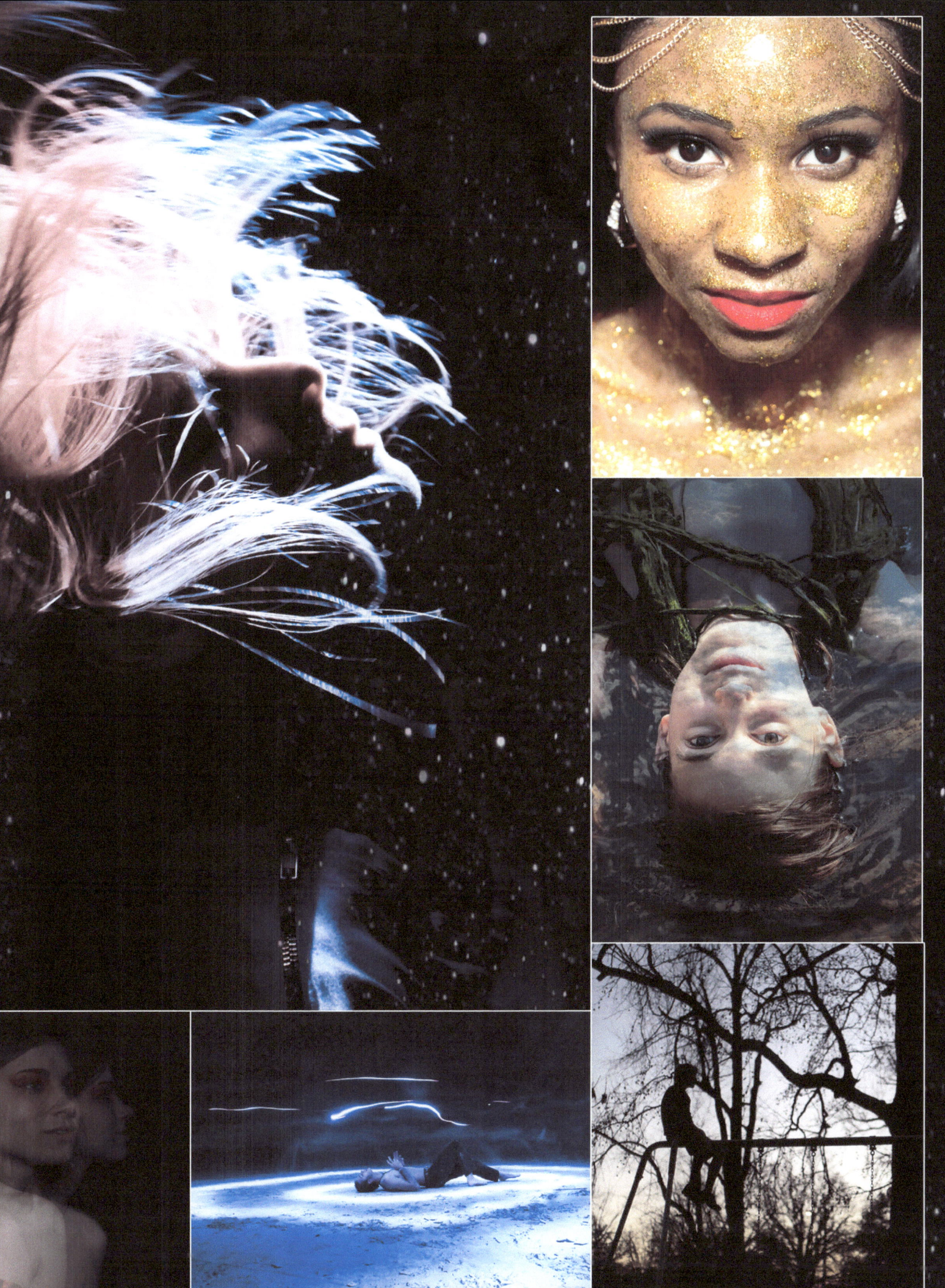

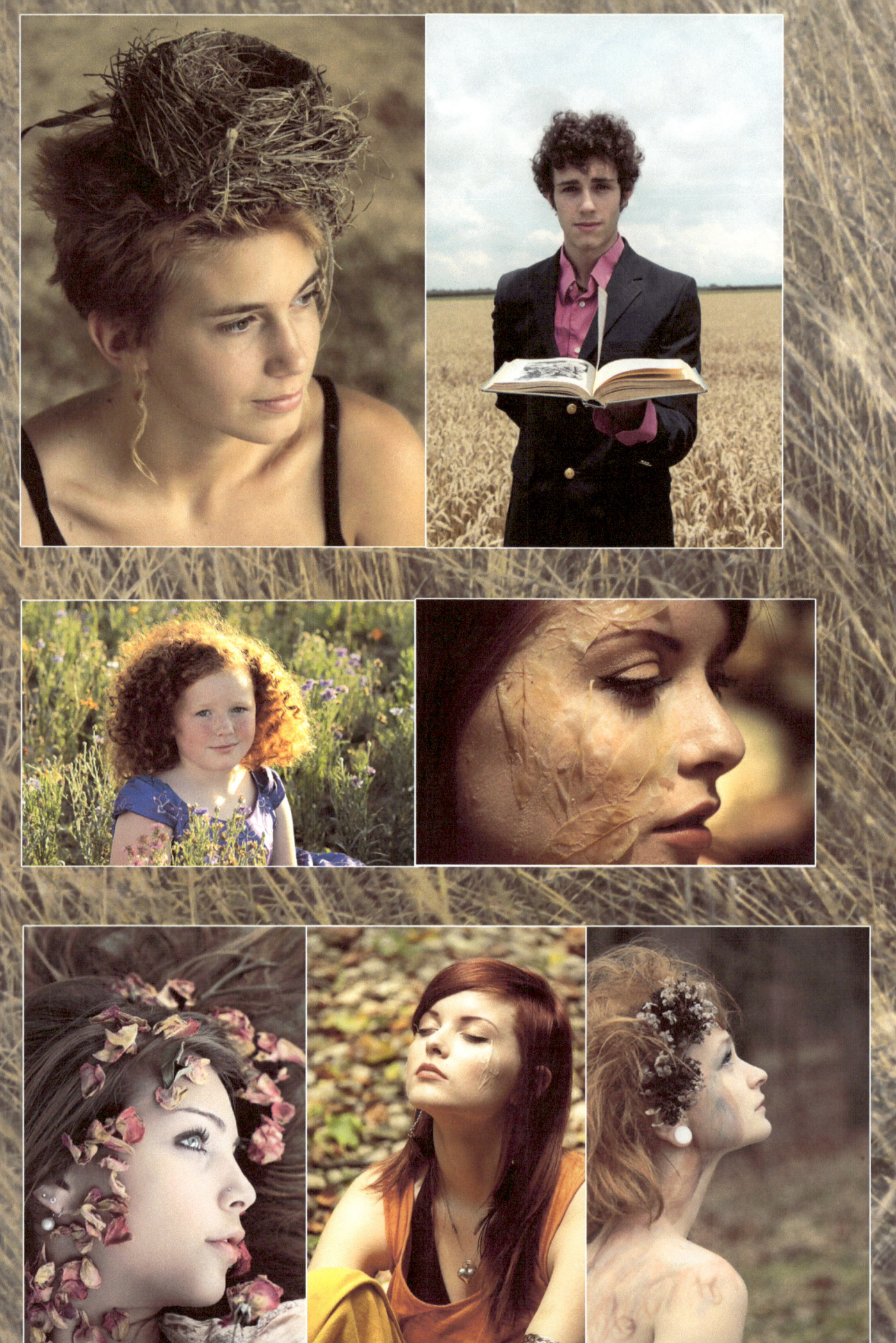

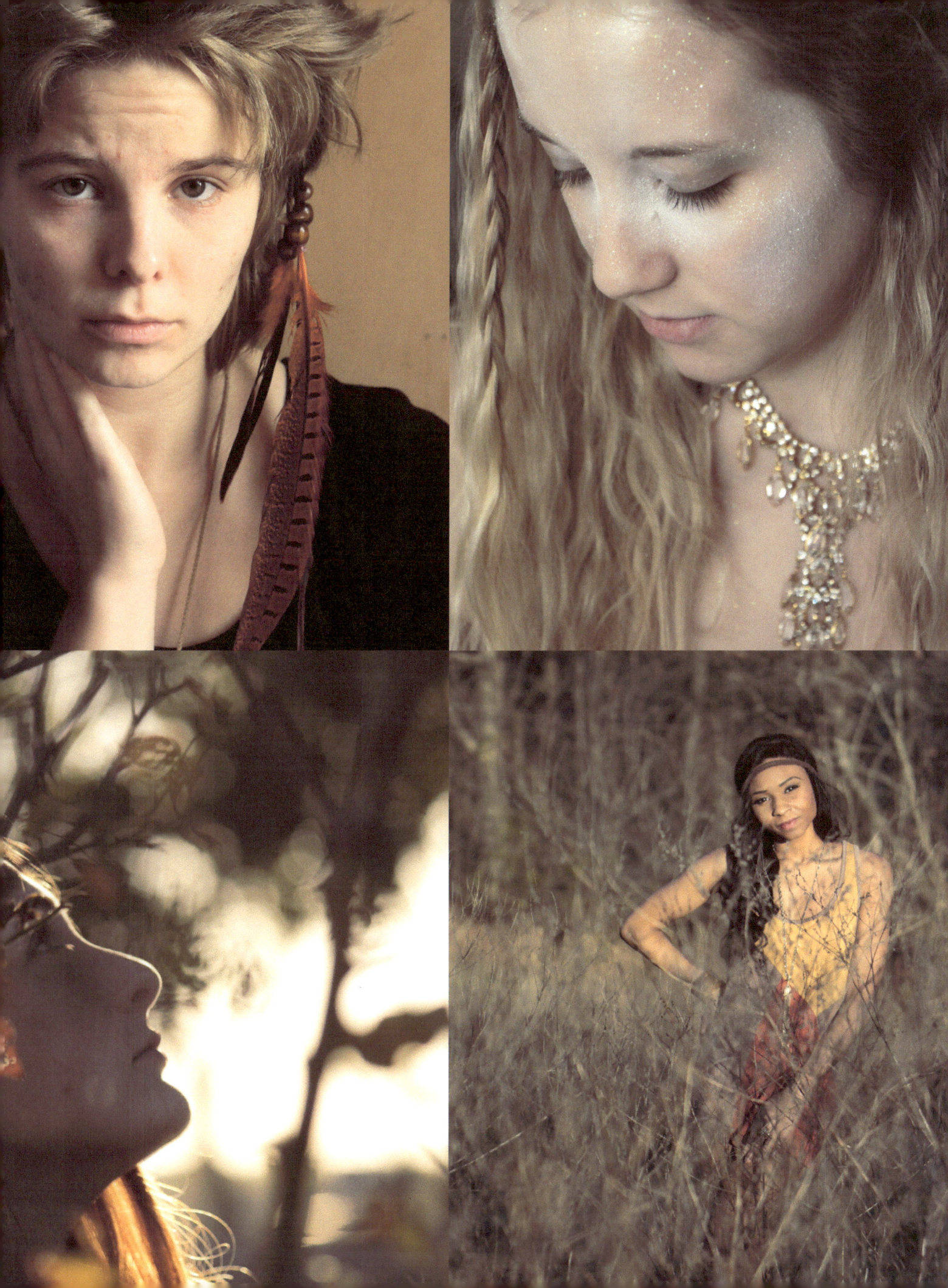

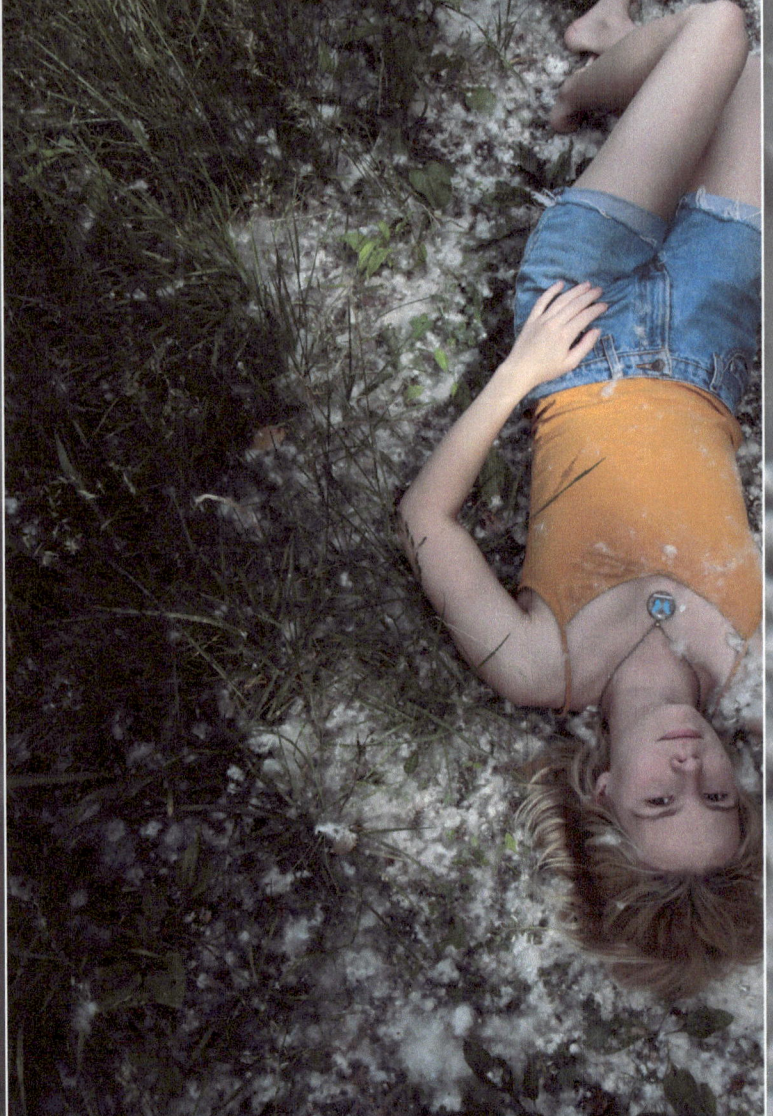
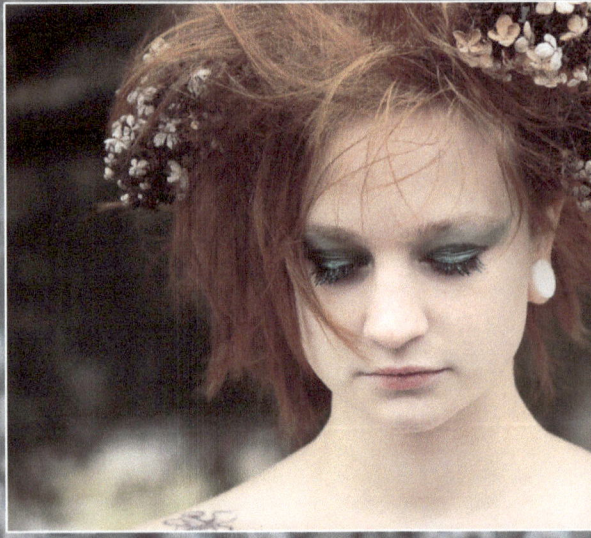
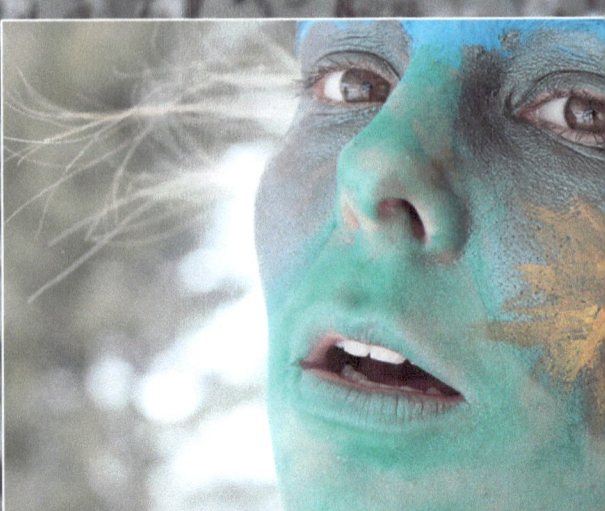

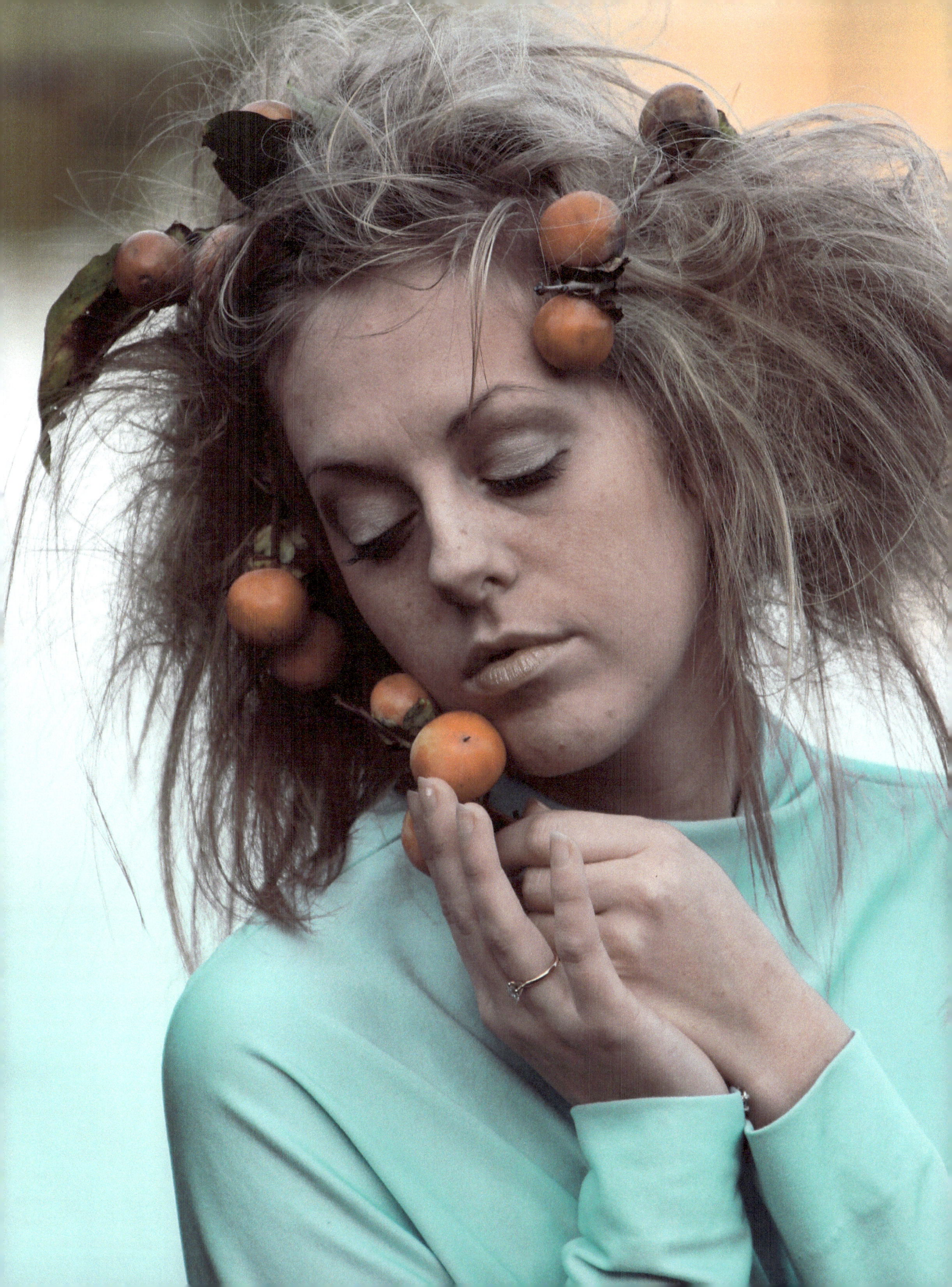

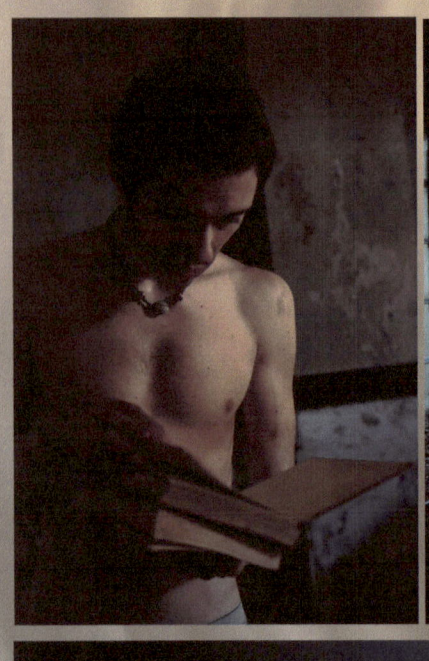
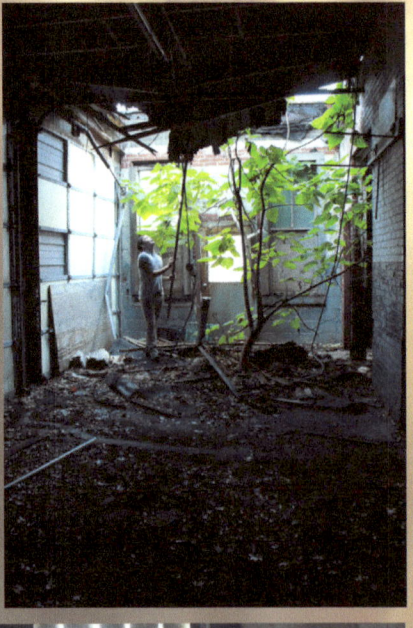
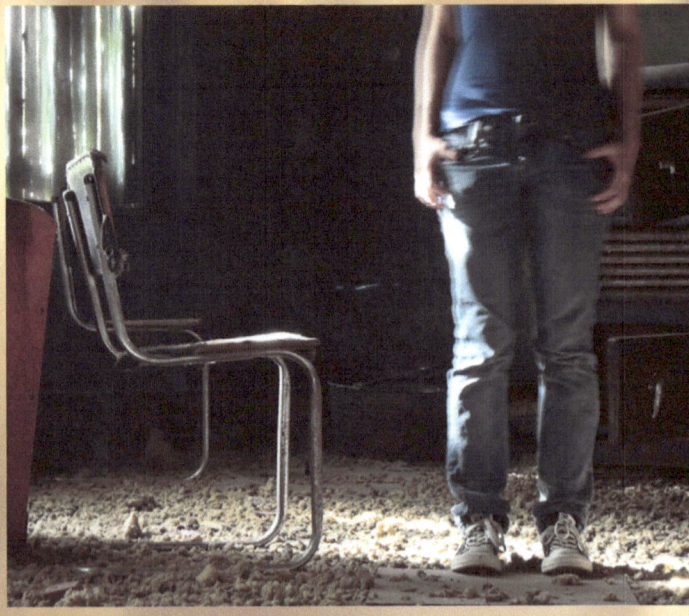
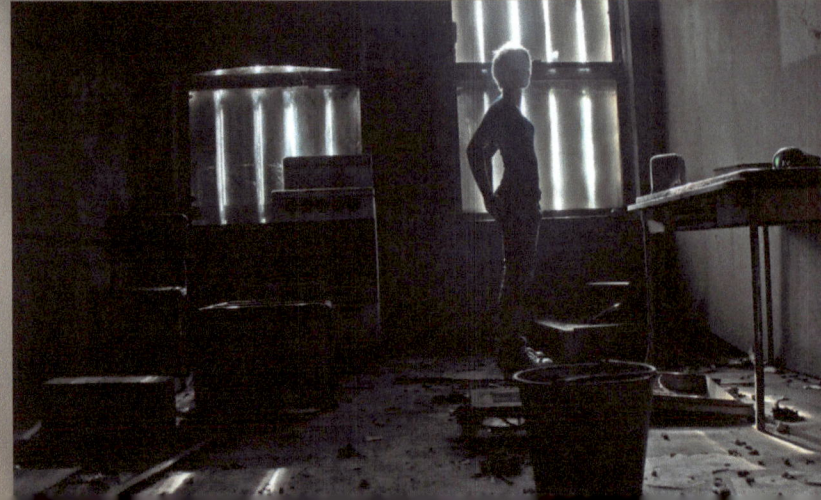
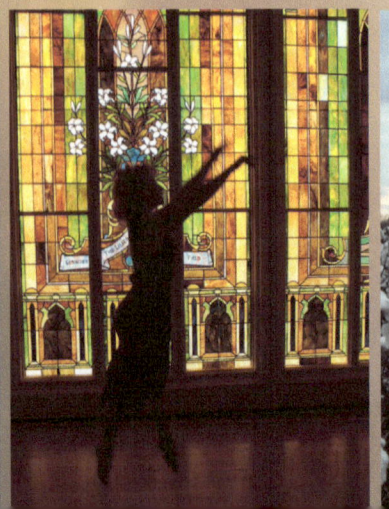
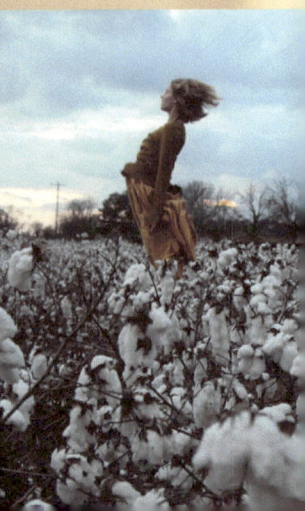

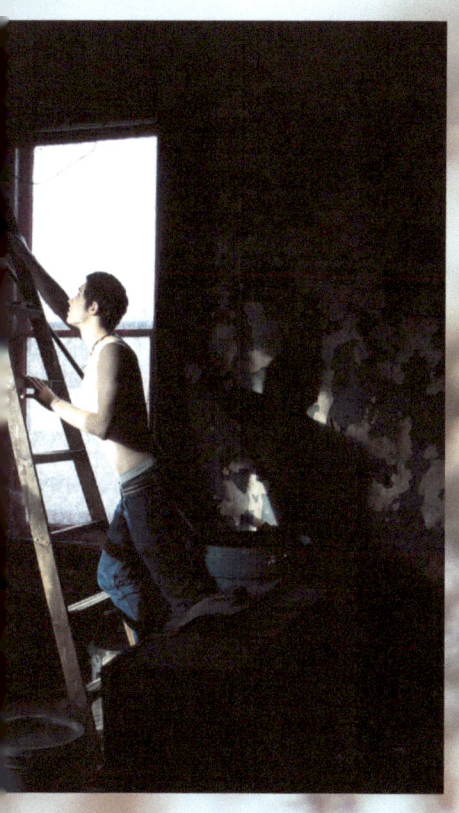
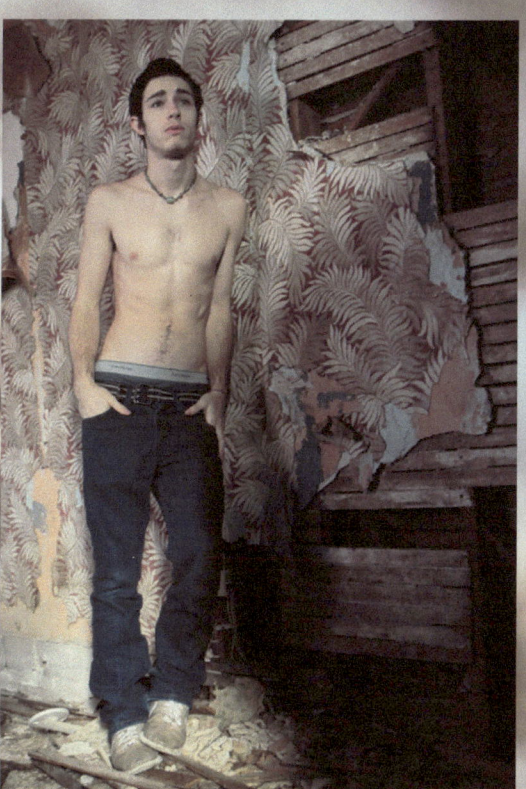
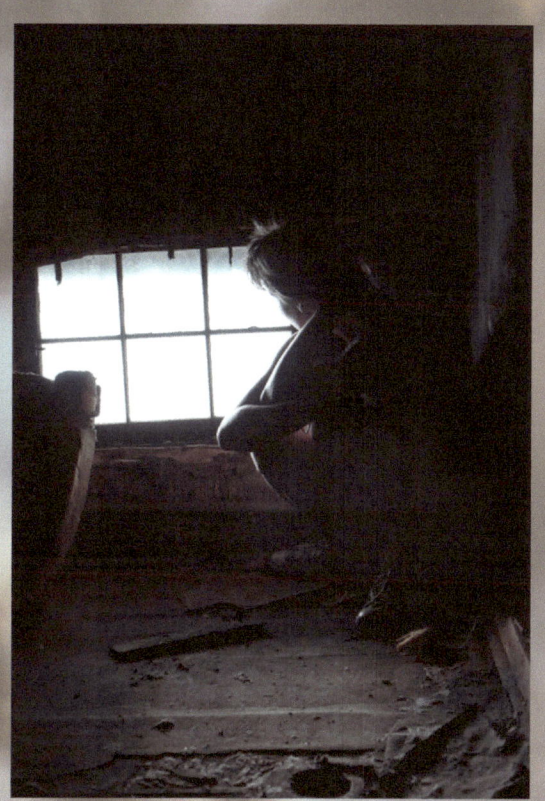

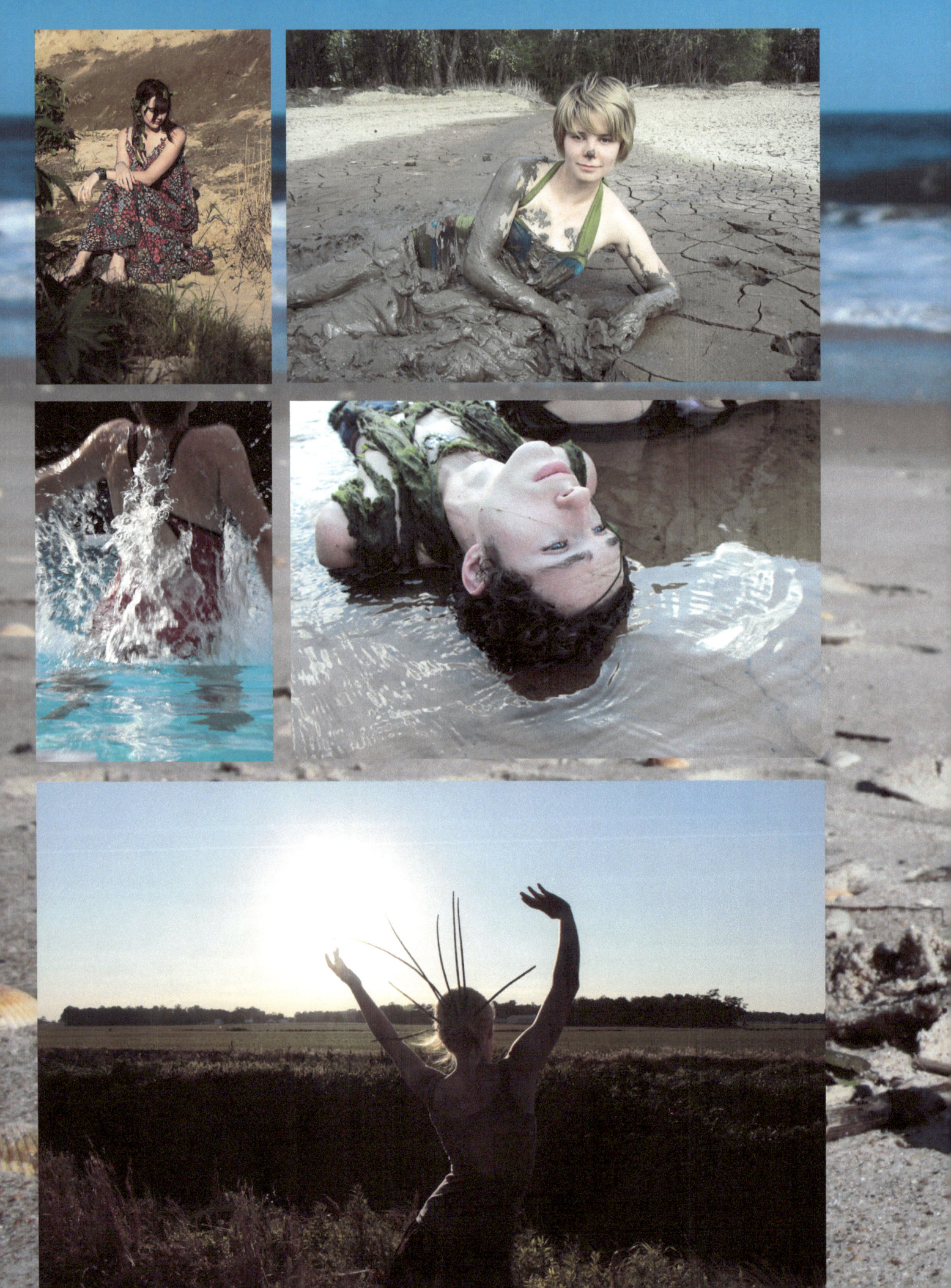

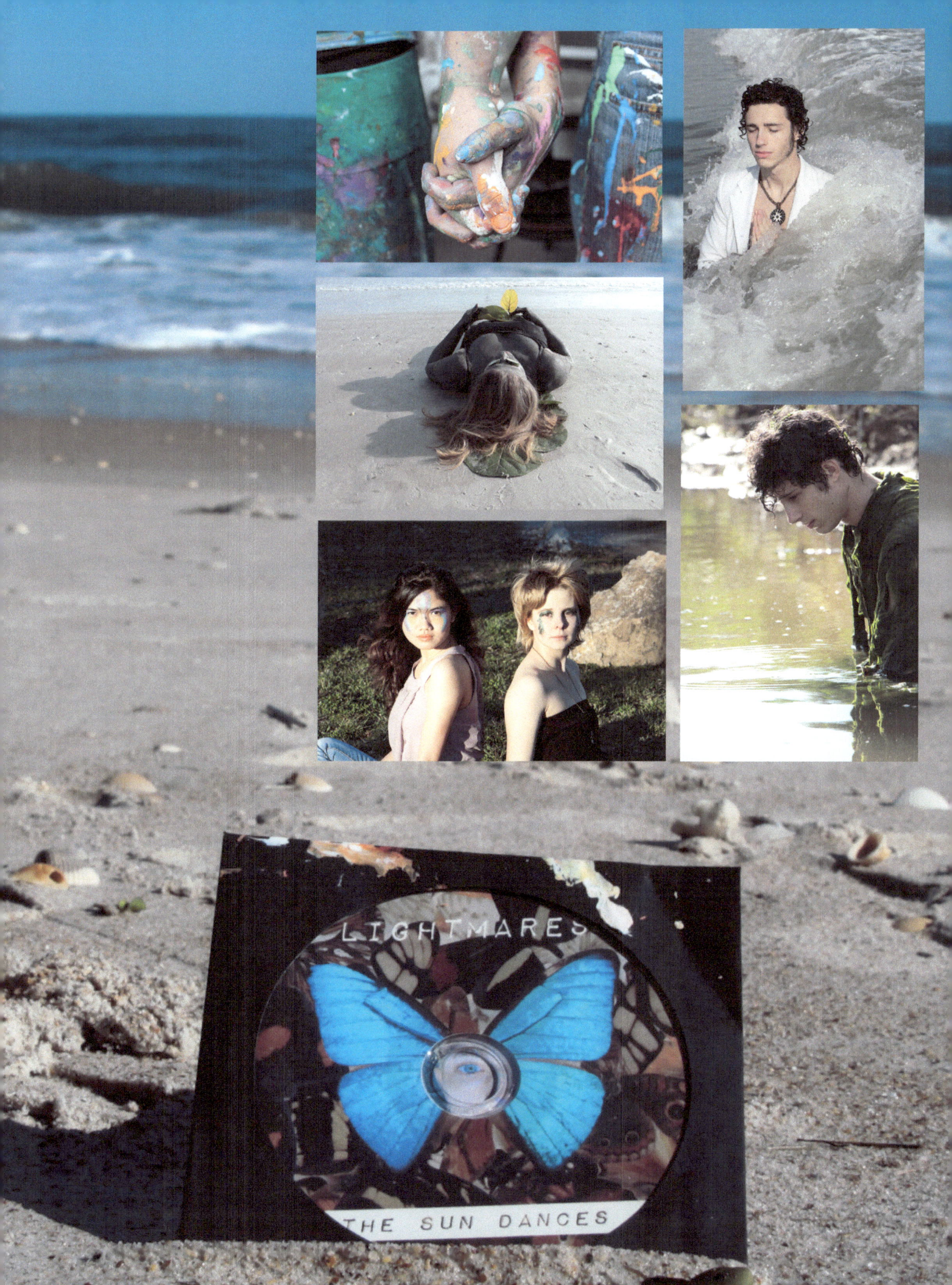

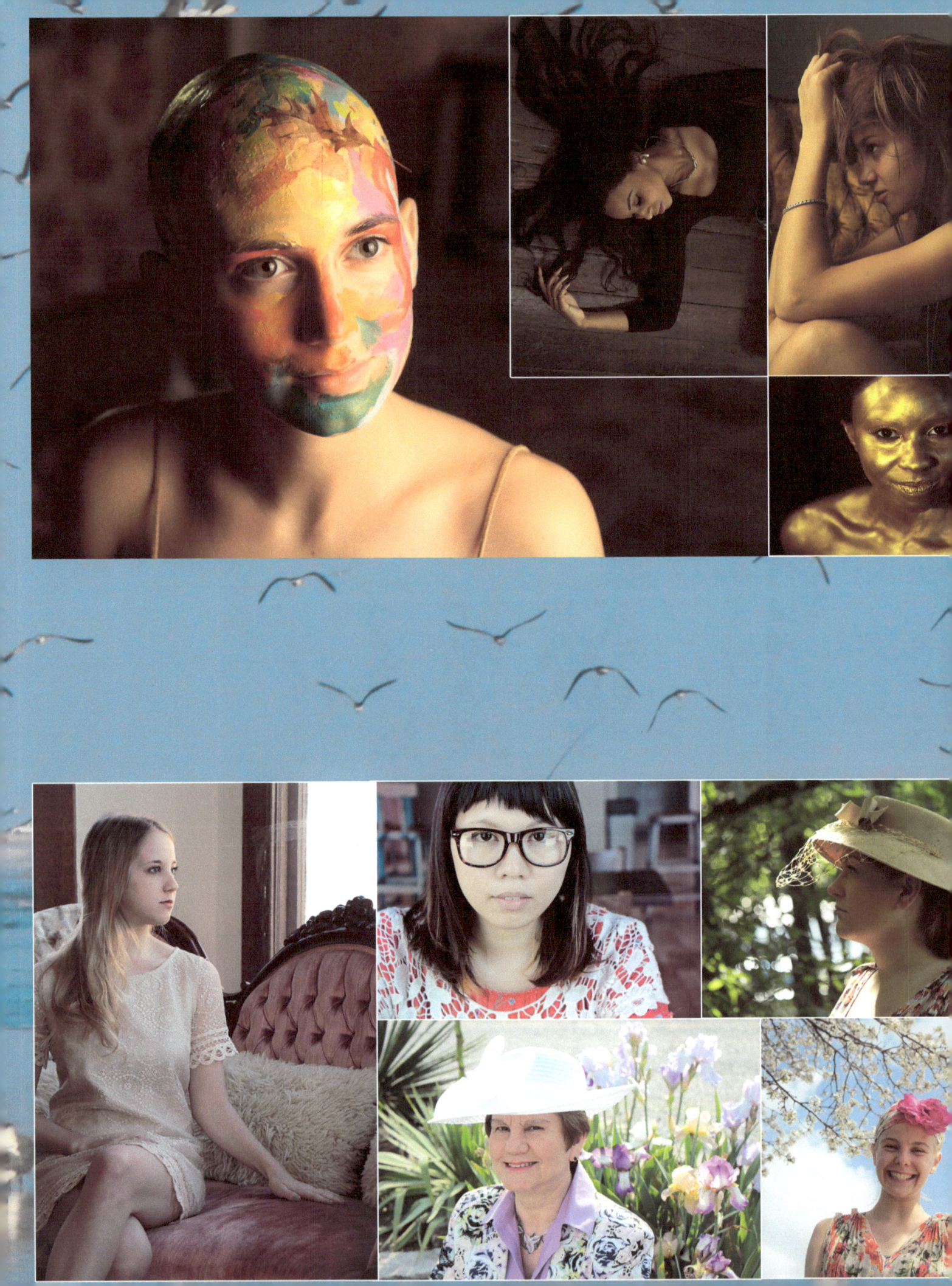

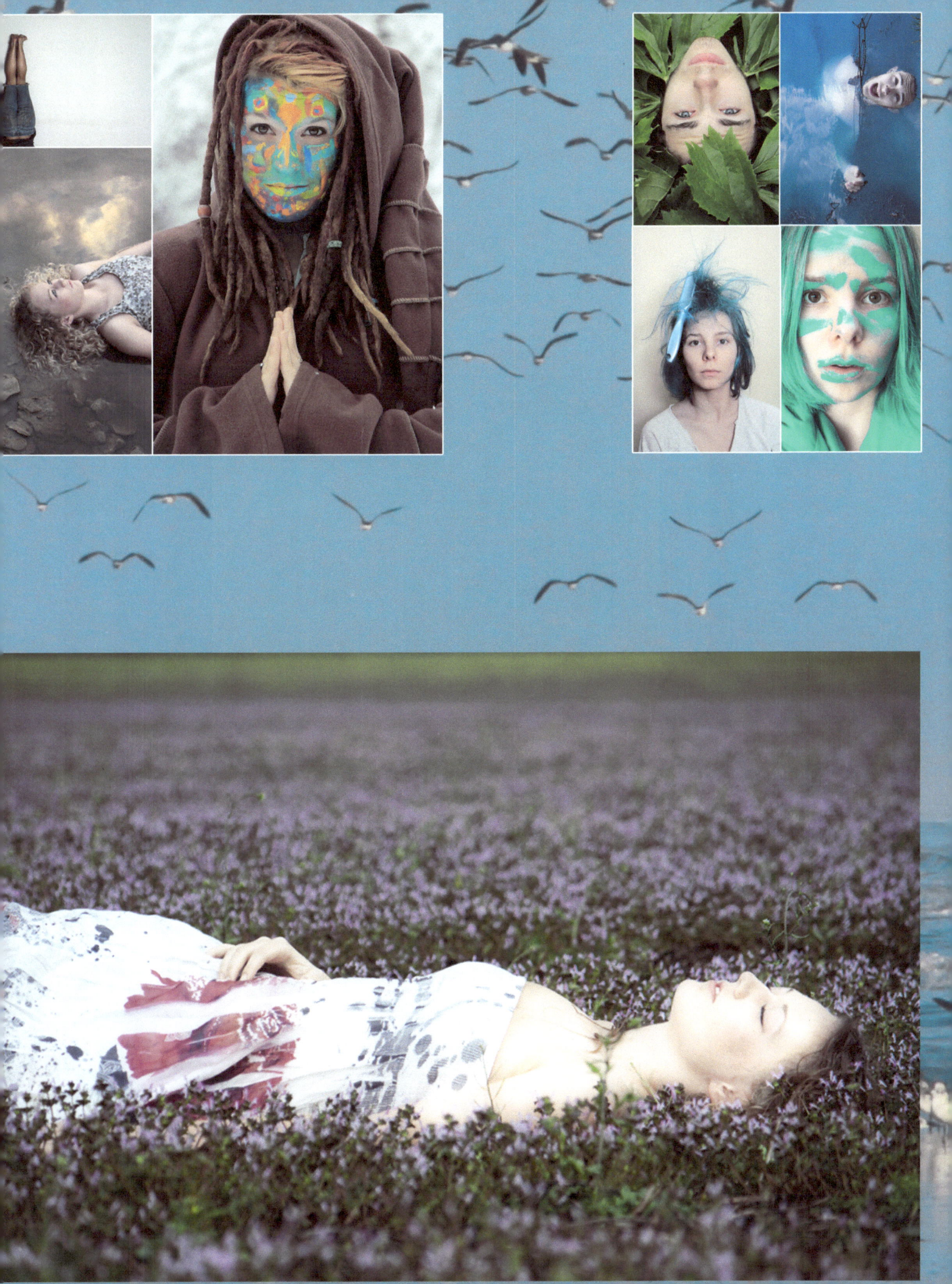

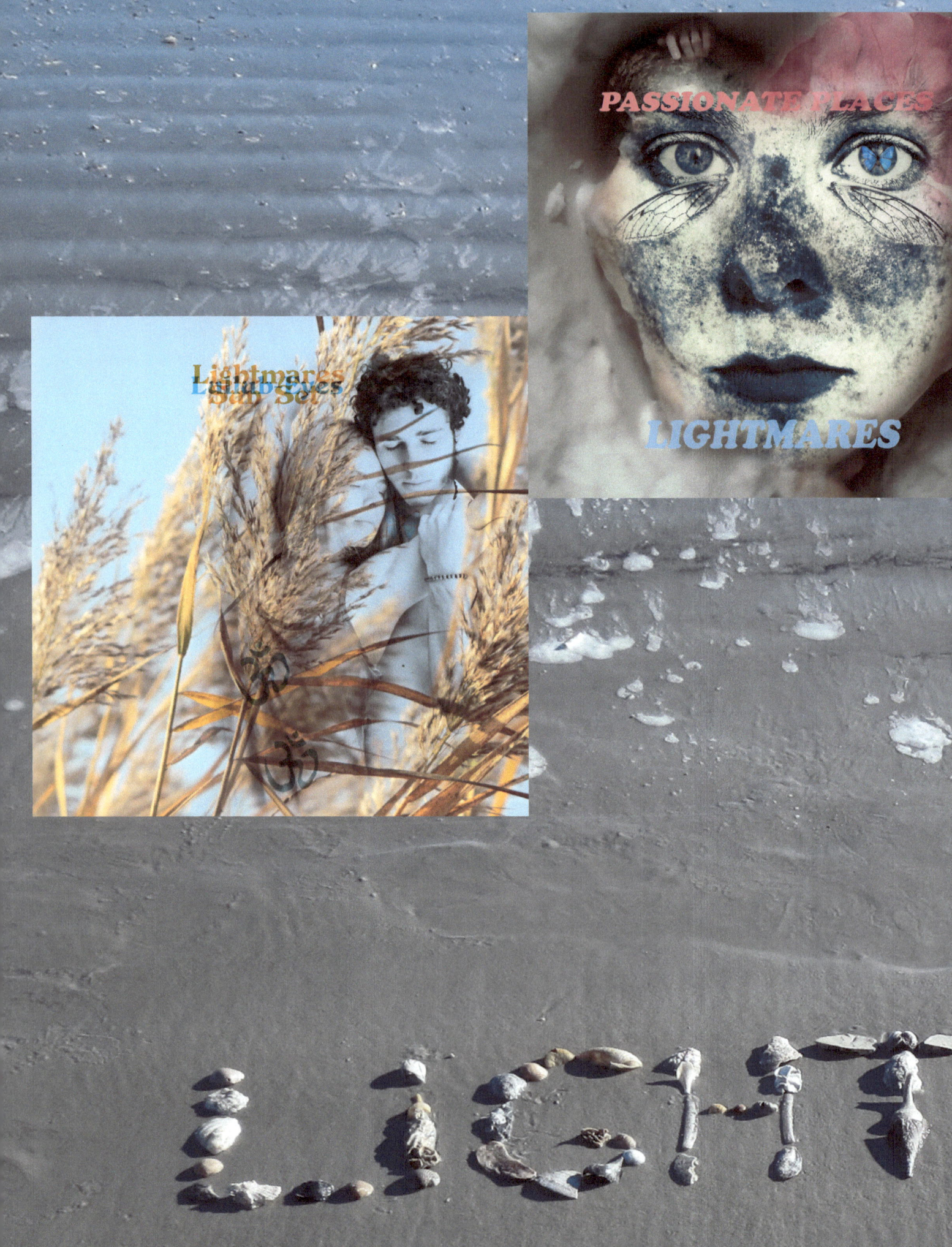

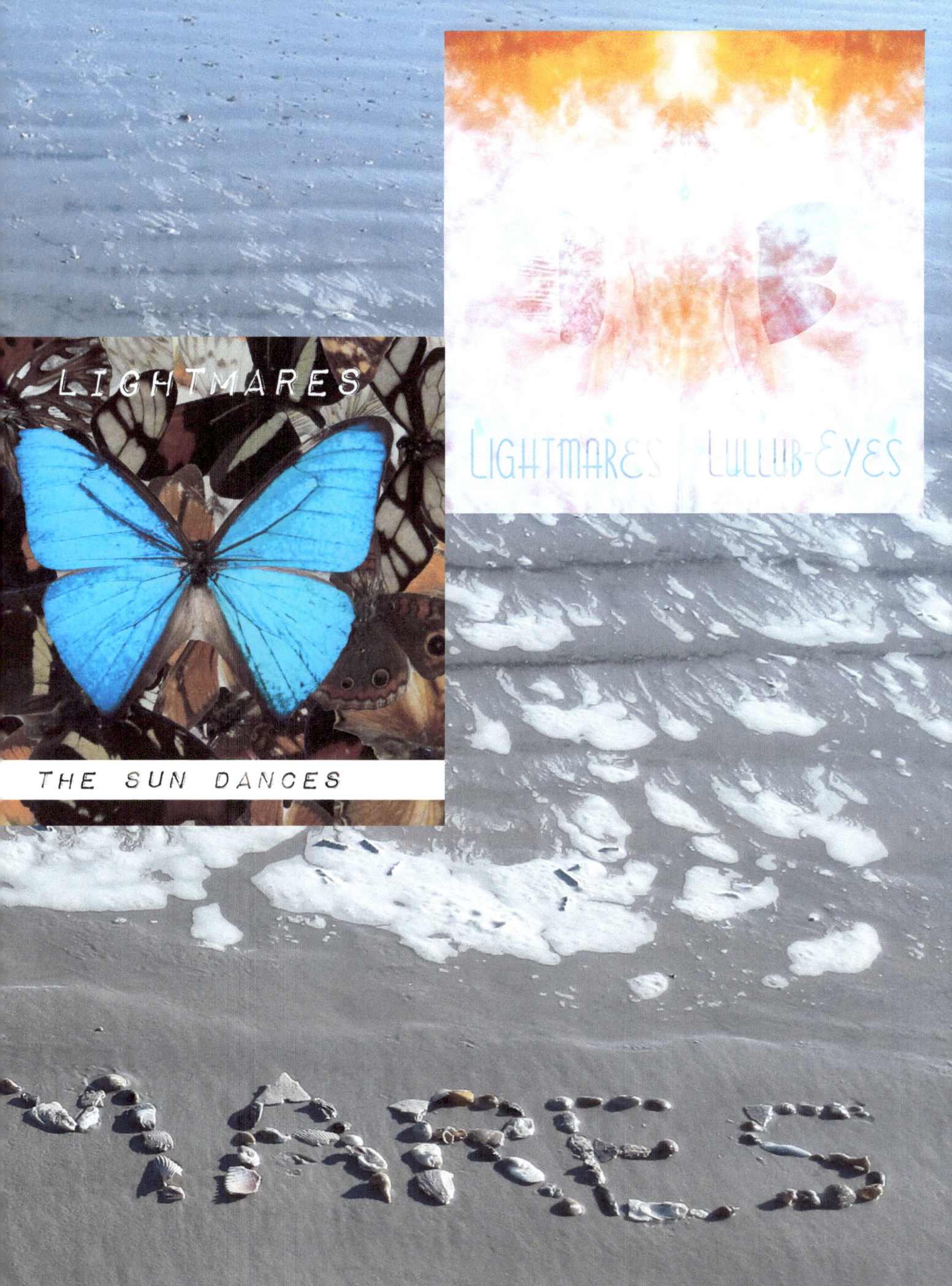

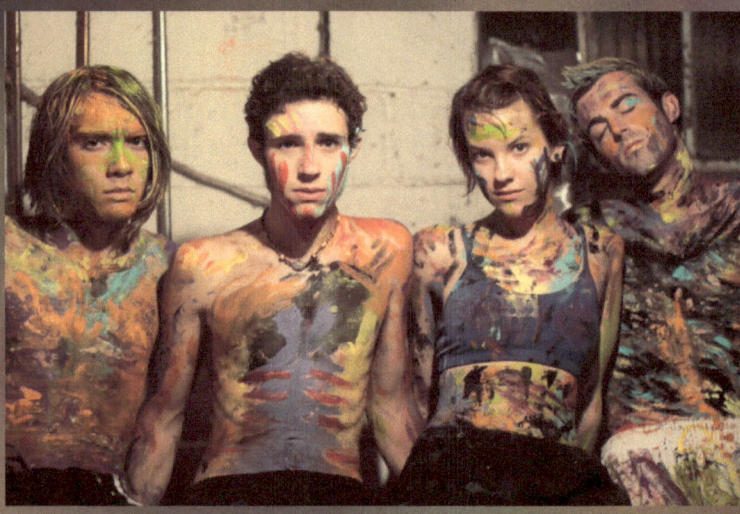
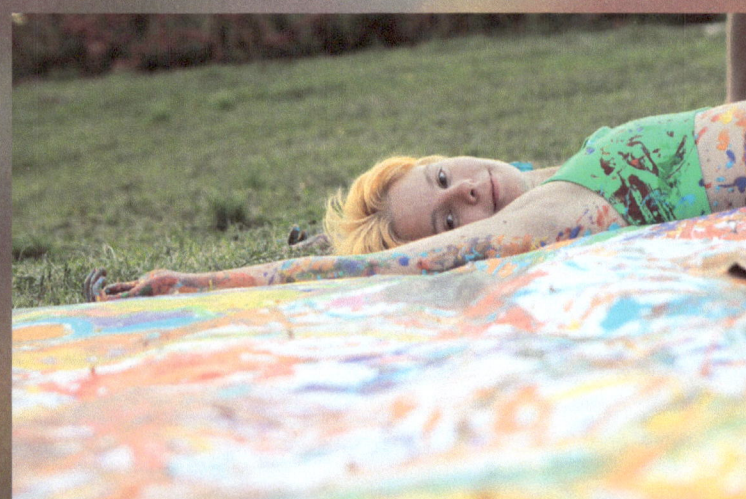

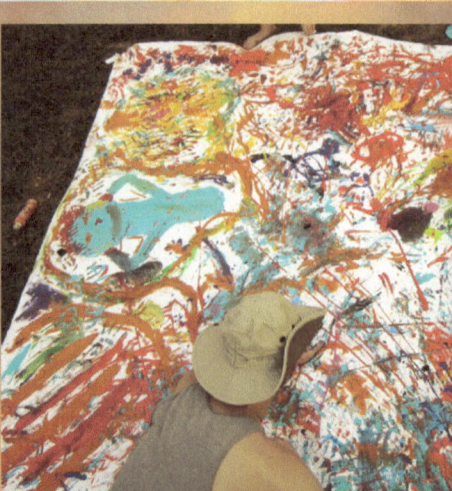

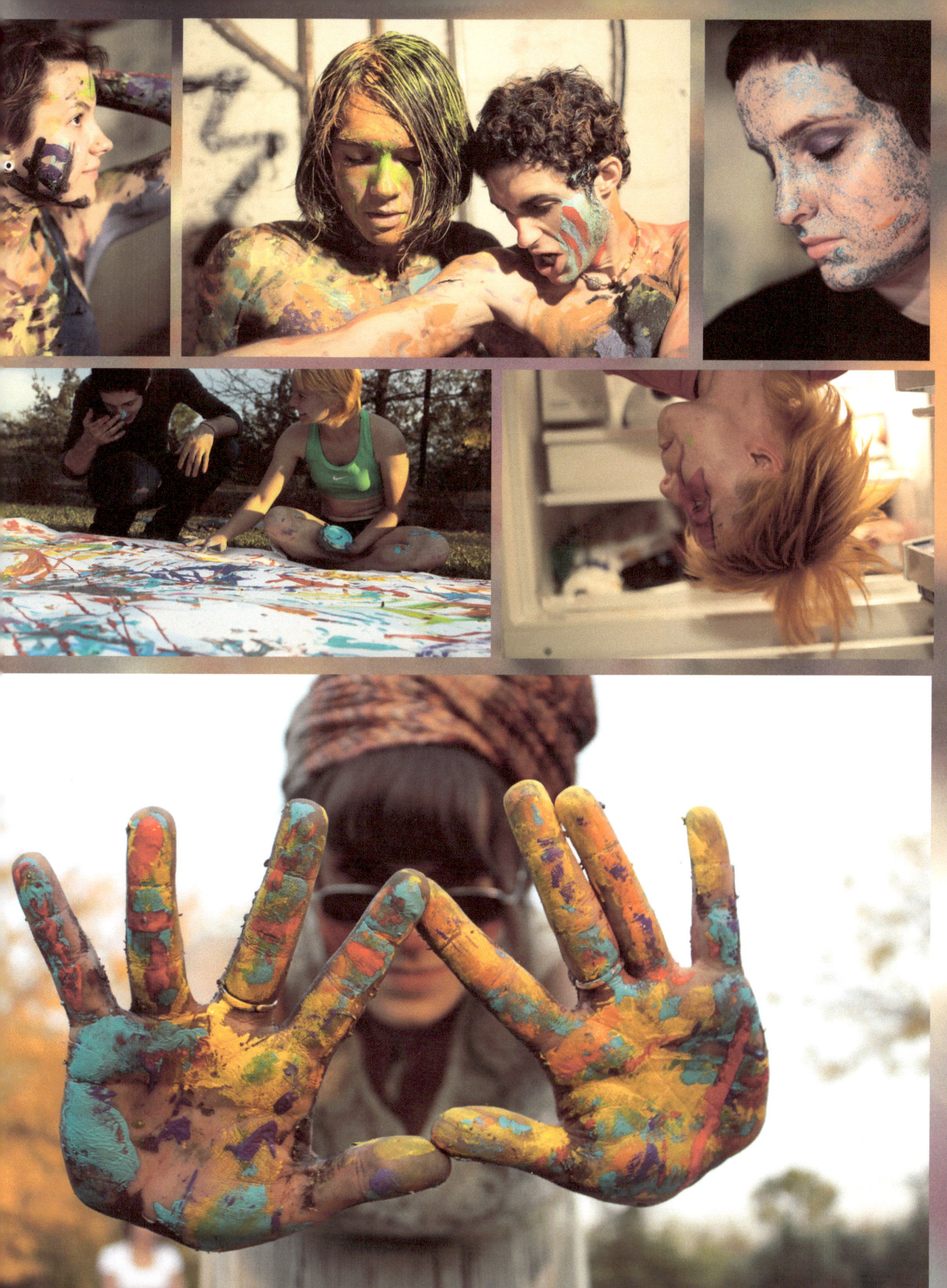

www.ingramcontent.com/pod-product-compliance
Lightning Source LLC
Chambersburg PA
CBHW050412180526
45159CB00005B/2247